Ladies of the *Brown*

In Honor of Former First Lady

Mamie D. Eisenhower

This book is presented by

Centennial Republican Women
Club Name

Colorado
State Federation

In Honor/Memory of

Colorado's Pioneer Women

Under the sponsorship of the
National Federation of Republican Women
124 N. Alfred Street, Alexandria, VA 22314-3011

Ladies of the *Brown*

A WOMEN'S HISTORY OF DENVER'S MOST ELEGANT HOTEL

Debra B. Faulkner

Charleston · London

THE
History
PRESS

Published by The History Press
Charleston, SC 29403
www.historypress.net

Front cover: top: etching of the Brown Palace, circa 1893, from
The Brown Palace Hotel, in-house publication; *bottom:* ladies' string quintet, from the Calvin
Morse scrapbooks, circa 1910. *Back cover:* ladies taking Afternoon Tea, circa 1910, from the
Calvin More scrapbooks.
Images courtesy of the Brown Palace unless otherwise stated.

First published 2010
Second printing 2011
Manufactured in the United States
ISBN 978.1.60949.128.4

Faulkner, Debra B.
Ladies of the Brown : a women's history of Denver's most elegant hotel / Debra Faulkner.
p. cm.
Includes bibliographical references and index.
ISBN 978-1-60949-128-4
1. Brown Palace Hotel--History--Anecdotes. 2. Brown Palace Hotel--Biography--
Anecdotes. 3. Women--Colorado--Denver--Biography--Anecdotes. 4. Denver (Colo.)--
Biography--Anecdotes. 5. Women--Colorado--Denver--Social life and customs--Anecdotes.
6. Denver (Colo.)--Social life and customs--Anecdotes. 7. Denver (Colo.)--History--
Anecdotes. I. Title.

TX941.B78F28 2010
910.4609788'83--dc22
2010044195

This book is respectfully dedicated to Julia Kanellos, passionate guardian of Brown Palace treasures and memories for more than a decade.

Contents

CONTENTS

Acknowledgements

The History Press initially contacted me soliciting a collection of "ghost" stories from the Brown Palace. Like so many old hotels and mansions, the Brown has its share of "unexplained phenomena." But unlike places that capitalize on their spurious specters, Denver's most venerable hotel has a lot more going for it. Commissioning Editor Becky LeJeune took a chance in agreeing to let me instead approach the Brown's story from a women's history perspective, an area into which the publishers had never before ventured. I appreciate her open mind and the confidence she placed in me, and I hope this book will encourage The History Press to publish more women's histories in the future.

My most profound thanks are due Julia Kanellos, my predecessor as Brown Palace historian. She bequeathed me a treasure-trove of archival materials from which to draw for *Ladies of the Brown*. Building on and further organizing the invaluable assortment of both primary and secondary sources originally assembled by the first hotel historian, Corinne Hunt, Kanellos created a rich basis for research, impressive in both its breadth and depth. I am immeasurably indebted to both ladies for making this project possible, allowing me to combine my two greatest passions, Colorado and women's history. Additionally, Julia's meticulous content and style review of my manuscript helped to ensure not only accuracy and readability but also that my writing did justice to the stories of both the ladies and the hotel. I like to think that this is the book Julia would have written had she not been so busy pursuing her master's of library science at the University of North Texas.

ACKNOWLEDGEMENTS

Special thanks to Marcel Pitton, managing director of the Brown Palace, and to his wife, Pam, for their support of this project. Mark Shine, director of sales and marketing, generously allowed me to scan and to use images from the hotel's archives. From guest registers to scrapbooks and postcards to menus, these bits of ephemera have contributed immeasurably to representing changes in the Brown Palace and in its social context over more than a century of operation. Unless otherwise credited in the captions, all images in this book were mined from the rich resources of the Brown Palace archives.

Coi Gehrig, photo imaging specialist with the Denver Public Library Western History Collection, could not have been more wonderful to work with. And though History Colorado (formerly the Colorado Historical Society) has technically "gone dark" until the completion of its new home in 2012, Jennifer Vega in its photo department provided timely and cordial attention to my requests.

My sincere appreciation goes to Dr. Thomas Couch of the Owyhee County Historical Museum & Library, Nancy Marshall of the Mountain Home Historical Museum and Philip Homan for kindly providing both information and images relating to the life of Idaho's "Queen of Diamonds." Thanks to Betty Lynne Hull and the Gurtler family, Emily Griffith Opportunity School and Jenna Robbins for granting me the privilege of including their archival and personal photographs.

For sharing their own stories, I am most grateful to Marge Harmon, Corinne Hunt, Charlene Orr-Webb and Barbara Goodrich. Fellow Colorado historians Tom Noel and Joyce Lohse provided answers to my many questions, the wisdom of their experience and endless encouragement.

I acknowledge my debt to all of the people who have taken my historical tours of the Brown and to the students in my Metropolitan State College Colorado history classes for teaching me what sorts of stories resonate with them. They've helped me to improve the way I bring history to life, both in person and in print.

My mother, Laurel Benson, drew me into the excitement of Colorado history from a very young age. Her enthusiasm for her adopted state and for the colorful characters of its past was contagious. A writer and teacher herself, she has always inspired me by her example and supported me unconditionally.

My husband and best friend, James Faulkner, endured frozen dinners, shoddy housekeeping and periodic panic attacks throughout the creation of this book. He forgave my lousy time management and understood my determination to share the personal stories that enliven local history. He always does…which is why of all the ladies of the Brown, I consider myself the most fortunate.

Introduction

An Oasis of Elegance

Wealth is making fabulous progress in Colorado, but the Brown Palace is of itself proof that art and culture keep step with riches, and invention is no laggard. Once beneath its restful influences, the hardships and annoyances of travel are soon forgotten and replaced by the pleasant impressions produced by such surroundings, and the delightful buoyance of mind and body always imparted by the exhilarating atmosphere of this favored State.
—The Brown Palace Hotel, *in-house publication, circa 1893*

The history of the Brown Palace is deeply intertwined with the history of Denver and the American West. Though the Brown Palace is best known for catering to masculine power brokers of the Rocky Mountain Empire, the Grande Dame of Denver's hotels has always enchanted the fairer sex. From the moment it opened in 1892, the Brown's elegance and ambiance have drawn ladies who appreciate the finer things. The venerable venue has set the stage for countless scenes of romance and scandal, new beginnings and cherished memories. In ways significant or small, the Brown touches everyone who passes through its doors.

Founder Henry C. Brown arrived on the Denver scene in the wake of the 1859 "Pikes Peak or Bust!" gold rush. In a stroke of real estate genius, Brown gave ten acres on a hill in the middle of his homestead to the territory of Colorado in 1868. The hill Henry called "Brown's Bluff" made a commanding site for the proposed state capitol building.

Brown's gesture was more shrewd than generous. He knew that the magnificent government edifice would increase demand for his surrounding

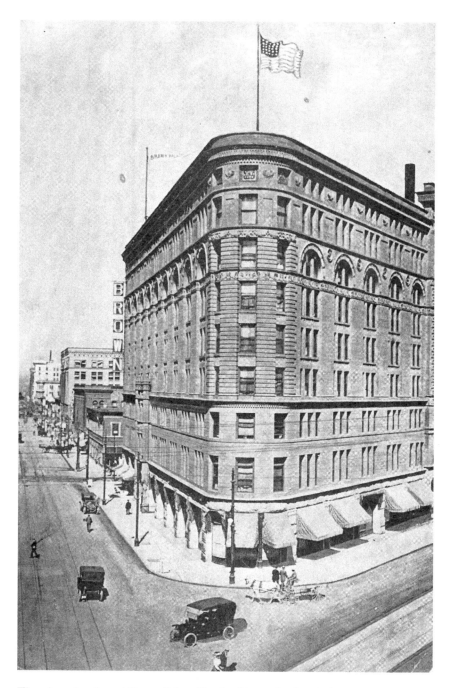

The triangular-shaped Brown Palace Hotel, a Denver landmark since 1892.

An impressive expenditure for 1892.

property holdings. Other state office buildings and the showcase mansions of Denver's wealthiest citizens soon crowned Capitol Hill. The resulting development became the basis of Henry's fortune, as he diversified into banking, railroads and other investments.

Brown was a very rich man by the late 1880s, when he was approached to front the venture capital for a hotel of unprecedented grandeur, unlike anything yet seen in the West. Financing guaranteed him naming rights. When the red stone Romanesque structure opened after four years' construction, it was as Henry C. Brown's Palace Hotel. The total price tag of $2 million—an astonishing sum in the late nineteenth century—reflected the builders' insistence on the best of everything, from electric light fixtures and hydraulic elevators to custom Haviland china and Reed & Barton silver.

The unique triangular building is widely considered the crown jewel of architect Frank E. Edbrooke's impressive portfolio. Recruited from Chicago to design the Tabor Grand Opera House, he chose to remain in Denver and became the second state capitol architect. Ultimately, he created or added to seventy-three local buildings, many still among the finest in the city.

In collaboration with Henry Brown, a builder himself, Edbrooke elected to design the palatial hotel's interior in the Italian Renaissance style. Its soaring eight-story atrium lobby features Florentine arches, intricate copperized cast-iron panels on the surrounding open balconies, 12,400 surface feet of golden onyx and a stained-glass skylight that casts a warm amber glow throughout the space, regardless of the weather. Were it to be magically transported to Venice or Florence, this breathtaking heart of the hotel would meld perfectly with its surroundings.

Long the setting for special occasions of all sorts, the atrium lobby is the area of the Brown Palace least changed over time. Much has been altered in a continual balancing act that weighs respect for the Brown's history against the need to remain a competitive, first-class hotel. Today's management recognizes that it is both the design and the history that make the Brown a singular experience.

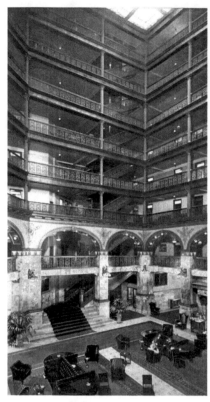

Left: The soaring Italian Renaissance–style atrium lobby.

Below: Brown Palace Bridal Suite, circa 1895.

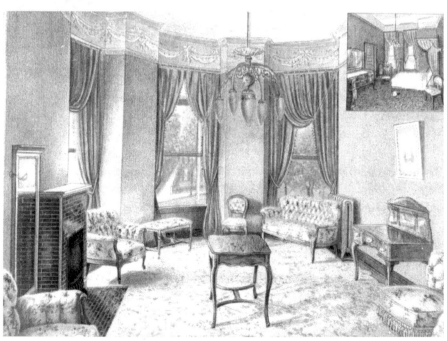

From the beginning, the Brown was considered one of the foremost hotels in the nation. Its nearly four hundred sumptuously appointed guest chambers attracted presidents, celebrities, royalty and high-powered businessmen—just as they do today. Each suite of rooms, priced from three dollars to a dizzying five dollars a night, offered the choice of steam heat or a fireplace. Pure artesian well water flowed from every tap, then as now. Toilets flushed. Call buttons summoned service. Hotel stationery proudly featured the Brown's "Absolutely Fireproof" assurance.

Over the decades, this extraordinary building has hosted some extraordinary ladies. Guest registers from the early years display page after page of gentlemen's signatures, often followed by "and Wife." Women's roles were changing as the last century turned and the hotel debuted. Their purview grew beyond the domestic sphere, and their newfound independence pushed the Victorian-era envelope. Some adventurous females traveled with lady friends. An intrepid few even embarked upon journeys—gasp!—alone.

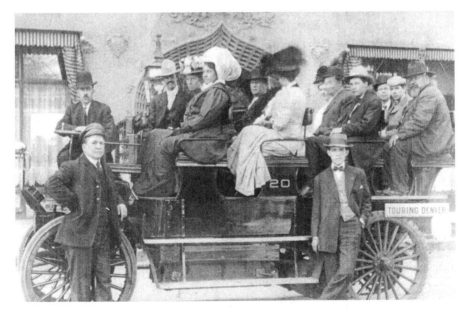

Touring cars set out from the hotel's Grand Entrance.

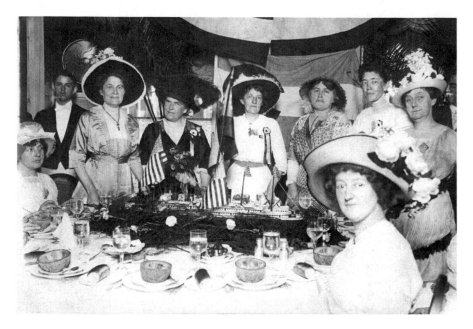

Progressive-era women, circa 1910.

Well-heeled society women ventured into "municipal housekeeping" and politics, leveraging the considerable clout of women's clubs to campaign for everything from child labor laws and safety regulations to temperance and suffrage. Bicycles and bloomers liberated ladies as never before. The definition of a woman's place was expanding.

In the Brown Palace, women's places were clearly delineated. The Ladies Lounge on the first floor, the Grand Salon on the second floor and the Ladies Ordinary on the eighth floor welcomed and pampered the refined gentlewomen who sought feminine sanctuary.

Women found their place behind the scenes, as well, working in housekeeping, the hotel's laundry or the kitchens. Stenographers and switchboard operators, florists and seamstresses all contributed to the smooth running of the West's grandest public domicile. Today, Brown Palace female associates fill positions from concierge to security chief with aplomb.

Through economic booms and busts, the Brown Palace has remained a symbol of status, good taste and impeccable hospitality. It stands as an oasis of elegance in what explorer Stephen H. Long labeled in 1820 as "the Great American Desert." The incomparable hotel has always counted discerning women among its most ardent devotees.

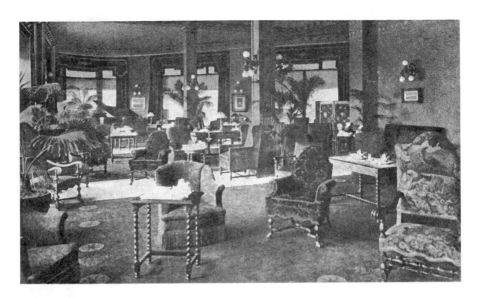

The Ladies Lounge.

The Grand Salon.

Ladies of the Brown, circa 1910, from the Calvin Morse scrapbook.

Males' tales have long overshadowed ladies' lore in western history. Gentleman builders and boosters, presidents and politicians have dominated biographies of the Brown. The feminine dimension of the hotel's heritage is due examination.

This sampling of ladies' stories reveals as much about evolving social, professional and public roles as it does about the Brown Palace and the developing American West. It reveals, as well, the strength of character, sense of adventure and persistent resiliency that distinguish truly uncommon ladies, past and present.

Part I

Legendary Ladies

Mrs. Henry C. Brown: A Three-Part Series

Jane Thompson Brown was exhausted. For six weeks she had been traveling with her husband, their infant son and a wagon loaded with their personal belongings. Their journey, mostly on foot, had launched from St. Louis, Missouri, for the West Coast, where Henry C. Brown had real estate interests in California and lumbering ventures in the Pacific Northwest. His wife collapsed wearily on a sandy hilltop overlooking the fledgling community of Denver. She gazed at the majestic Rocky Mountains that lay ahead of them and envisioned the crossing with a baby and a team of plodding oxen. Jane Brown was no quitter. But neither was she foolhardy. As a Quaker, she was disinclined to battle. She made a decision and communicated it as simply and as plainly as possible. Henry was free to continue on to California, she informed him. But she would go no farther.

Thus it was a woman who compelled Henry Brown to settle, once and for all, in Colorado Territory. Her influence would have unimagined consequences, including the designation of Denver as the future state's capital and the erection of the Brown Palace Hotel, the grandest hostelry in the American West.

Henry C. Brown's first wife had the perfect maiden name for a hotelier's spouse. Anna Louise Innskeep married Henry in 1841 in Ohio. Almost before he knew it, young Henry had two children, Benjamin Franklin and Anna Mary. He also had itchy feet.

Jane Cory Thompson, the second
Mrs. Henry C. Brown.

Too much time in one place made Henry restless. He was a carpenter with bigger dreams of a business empire. During his marriage to Anna Louise, he set off on multiple ambitious treks around the tip of South America en route to the West Coast. His search for investment opportunities even took him to South America for an extended stay of five years. He returned at last to discover two major developments. One, his wife had passed away. Two, his children were being raised by their maternal grandparents. They seemed to be doing well in their new circumstances, so Henry saw no reason to tarry. Soon he was off again, this time to the frontier community of St. Louis.

It was here that he met and married schoolteacher Jane Cory Thompson. When son James was born in 1859, Henry's feet began to itch again. Jane would have none of it. She insisted that he cease his wandering ways and choose a place to call home. He chose California. But he ended up in Pike's Peak Country. His intention was never to prospect for gold himself but rather to "mine the miners." For a carpenter such as himself, the burgeoning supply town of Denver provided plentiful opportunities.

Henry built his carpentry shop and a modest boardinghouse along the banks of Cherry Creek near the confluence with the South Platte River. All was well until the Flood of 1864, when his buildings, along with most of the settlement, were swept away. While some elected to rebuild, Henry decided to head for higher ground. He found a 160-acre homestead parcel southeast of town, which he acquired for just $200. While Henry undertook a bit of farming, Jane raised James and his two younger siblings, Carrie and Sherman. She joined other women determined to make the frontier settlement a kinder, gentler place. She helped to found the Denver Orphan's Home and supported its work with liberal contributions over the years. Though herself a Quaker, she was also a major contributor to the Methodist Church and its charities.

A gentleman farmer and real estate speculator, Henry optimistically began laying out streets and town lots on his property. The people of Denver

thought him crazy, believing that the city would never extend as far as his outlying homestead. Henry Brown was crazy—like a fox.

When competition raged between cities hoping to be designated the Colorado capital, Henry Brown clinched the deal for Denver in 1868 by donating ten hilltop acres in the middle of his property as a site for the new capitol building. The calculated "gift" transformed the Brown homestead into the Capitol Hill development and positioned Henry to build the grand hotel, in part at least, for his dear Jane.

The year after its opening was a difficult one for Henry Brown. The 1893 Silver Crash sent the Colorado economy into a decade-long economic depression. Even those not directly involved in silver mining felt the pinch. Henry had to mortgage the Brown Palace for $800,000, a fraction of its value. That same year, Jane, his beloved wife of more than thirty years, passed away.

By this time, Henry was seventy-four years old. A lesser man might have resigned himself to living out his remaining days alone. But Henry married for a third time. Mary Helen Matthews was a nineteen-year-old grocery store clerk when she wed the aging entrepreneur. By all accounts they were happy together at first. Perhaps Henry had discovered some Amazonian jungle plant with virility-boosting properties on his earlier South American travels!

But the spell was broken six years later when Mary Helen, in her mid-twenties, seems to have awakened to the fact that her spouse was an octogenarian. They divorced amicably. Mary returned most of the expensive gifts with which Henry had showered her, retaining only one necklace that held particular sentimental value. She then turned around and married John Douglas Campbell, a young man much closer to her own age.

Henry C. Brown lived to eighty-six, when he passed away in San Diego, California. Before he died, his namesake Palace was

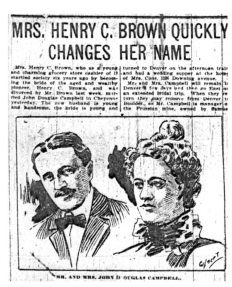

Mary Helen Matthews, the third Mrs. Henry C. Brown. From the *Denver Evening Post*, August 2, 1900.

purchased by Winfield Scott Stratton, a Cripple Creek gold millionaire. Following Stratton's death at about the same time as Brown's demise, there ensued years of court battles between the Brown heirs and the Stratton estate. Henry and Jane's son James, who had journeyed as an infant with his parents to Denver, fought to reclaim a share of the family's hotel legacy. Alas, his legal efforts were ultimately in vain. Henry and Jane now rest in peace under "Father" and "Mother" markers in the Brown family plot at Denver's historic Fairmount Cemetery.

AUGUSTA TABOR: CAST-OFF SPOUSE

When young Augusta Pearce wed Horace Austin Warner Tabor, one of her father's Maine quarry stonecutters, she could never have imagined that she would someday be remembered as a key player in Colorado history's most infamous soap opera. During her early years of struggle and hardship, she would never have dreamed that in later life she would find herself living in Denver's most luxurious hotel.

The newlywed Tabors set off to homestead in Kansas, where their son Maxcy was born in a log cabin on the prairie. When news of gold discoveries in the Pikes Peak Country in 1859 lured Horace farther west, Augusta dutifully packed up their young son and followed her restless husband.

Augusta Tabor was the epitome of pioneer womanhood. She was ladylike but hardworking, generous but frugal. Respectable, resourceful and resilient, she was often the first white woman to arrive in the rough-and-ready mountain mining camps. While Horace prospected with limited success, Augusta made a steady income taking in laundry and boarders. She kept the family solvent as Horace dragged them from one boomtown to another.

By the time they moved to Leadville, Colorado, in the late 1870s, Augusta had scrimped and saved enough to set them up in a general store. In so doing, she unknowingly positioned Horace to make a move that would forever transform their lives.

Leadville was booming with discovery—not of gold but of silver. Horace "grubstaked" a couple of prospectors, exchanging supplies for a share in anything the miners might find. More often than not, a storekeeper ended up writing off the transaction as a total loss. But these particular prospectors got lucky—incredibly lucky. Horace found himself with one-third ownership in the Little Pittsburgh Mine, a windfall beyond his wildest expectations.

He invested the hefty proceeds in other Leadville mines, and almost overnight, Horace Tabor became one of Colorado's foremost Silver Kings.

Horace Tabor wasted no time flaunting his newfound fortune. He spent like Midas on impressive new buildings, fine clothes and all of the luxuries he had done without for so many years. He wanted his wife, too, to wallow happily in their wealth. But the very idea was repugnant to the prudent Augusta. She considered her husband's ostentatious displays of money vulgar and foolhardy, and she criticized him continually.

When Horace was appointed lieutenant governor in 1878, he moved Augusta into a Denver mansion on Broadway. It was, in fact, the very

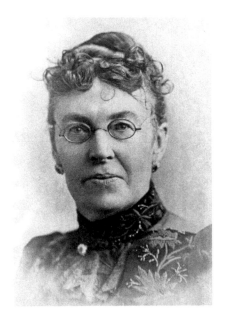

Augusta Pearce Tabor. *Courtesy Denver Public Library, Western History Collection.*

mansion built by Henry C. Brown and home to his family for many years. Augusta hated it. It was much too big for her modest needs. Rather than enjoying the life of ease she could now afford, Augusta took in boarders, just as she had always done. She continued to dress in her old clothes and eschew unnecessary comforts. This woman who had thrived in hardscrabble conditions did not take well to the lavish lifestyle and notoriety in which her husband reveled. The Tabors grew further and further apart.

Strawberry-blond Elizabeth McCourt Doe was beautiful, vivacious, divorced and young enough to be Horace Tabor's daughter. She was called "Baby" by the miners for her cherubic features. She was all too happy to help the Silver King squander his riches, and they began a passionate affair. Augusta was willing to look the other way and always believed that Horace would return to her in the end. But Baby Doe grew tired of sneaking around. She wanted legitimacy and children. She finally insisted that Horace divorce Augusta and marry her.

Augusta at first refused to consider a divorce. Not only did she still truly love her husband, but her entire identity was also tied up in their relationship of twenty-six years. At last, the strain of humiliating publicity surrounding the scandal became too much for her. In a rare public display of emotion,

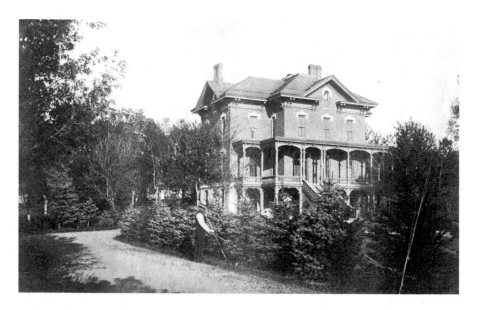

Augusta Tabor's Broadway house, previously home to Jane Brown. *Courtesy Denver Public Library, Western History Collection.*

she tearfully begged the presiding judge to let the record show that she granted the divorce "not willingly."

The fact that all of Denver sympathized with her plight was of little consolation. She soldiered on with a considerable settlement from the divorce, wisely managing the property that she acquired and investing in low-risk stocks. Horace and Elizabeth continued to splurge shamelessly on everything from gilded coaches to diamond diaper pins for their baby daughters. Augusta tried to caution her ex-husband to set something aside as a safeguard against unforeseen developments. But he had long ago stopped listening.

For four years, Augusta watched as a grand new hotel rose directly across Broadway from her house. Henry C. Brown's Palace Hotel eclipsed anything ever before erected in Denver. Augusta's son Maxcy, now a grown man, became an original co-manager of the hotel along with William "Billy" Bush, the man who had first introduced Horace to the fetching Ms. Doe in Leadville. Maxcy and Billy had previously worked together managing Denver's elegant Windsor Hotel and Leadville's Clarendon Hotel.

Knowing how uncomfortable his mother had always been in the Broadway mansion, Maxcy suggested that she take a suite in the Brown, where he lived with his French wife, the former Luella Babcock. Though

the polar opposite of her preferred simple style, Augusta seemed to find the hotel's tasteful opulence unobjectionable and settled in nicely. She rented the Broadway house to the Commercial Club of Denver and made it available for teas, lawn festivals and other charitable functions. Well known for her philanthropy, Augusta Tabor was one of the most generous contributors to Denver's Unitarian Church and the Pioneer Ladies Aid Society.

The Silver Crash of 1893 pulled the rug out from under the silver mining industry and sent Colorado's economy into a tailspin. Augusta took no satisfaction in watching Horace tumble from the pinnacle of wealth almost as quickly as he had initially risen. When he died in 1899, he left his second wife and two young daughters nearly penniless.

Augusta had moved on by then, both literally and figuratively. She lived in the Brown less than two years before following doctors' advice to seek a lower altitude for her health problems. She ended her days in the Balmoral Hotel in Pasadena, California, and died there in January 1895 on the eve of her thirty-eighth wedding anniversary. At the time of her death, she was one of the wealthiest women in the West.

Descendants of Augusta Tabor still travel from France to the Mile High City, where their forebears are legendary. They visit the grave sites of Horace, Augusta and Maxcy in three different local historic cemeteries. And they stay in the magnificent hotel where Great-Grandmother Persis Augusta was born to Maxcy and Luella in 1894.

Margaret "Molly" Brown: Titanic Heart

Undoubtedly the most prevalent misconception about the hotel's genesis is that it was in some way originated by the famous "Unsinkable Molly" Brown of *Titanic* fame. The assumption is understandable, since Margaret Tobin Brown lived in Denver for many years. The redoubtable Mrs. Brown's history did, indeed, intersect with that of the Brown Palace Hotel on multiple occasions, but she was absolutely no relation—by blood or by marriage—to the hotel's founder, Henry Cordes Brown.

Visitors who seek out the Molly Brown House Museum on Denver's Capitol Hill hoping to find something of the "Unsinkable Molly" portrayed in the MGM musical may be disappointed—initially, at any rate. Margaret Tobin Brown (sometimes called Maggie but never Molly in her lifetime) bore scant resemblance to petite and perky Debbie Reynolds who portrayed her

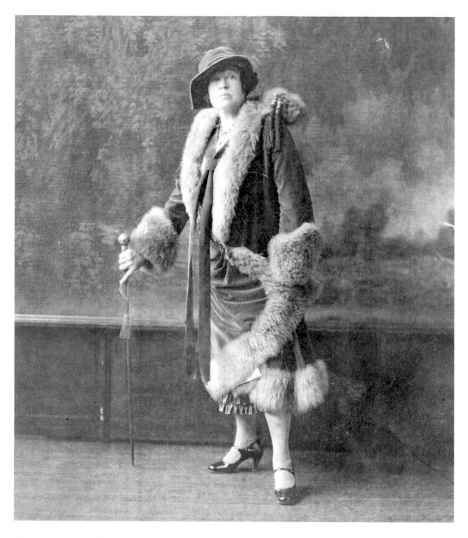

Margaret Tobin Brown, the "Unsinkable Molly." *Courtesy Denver Public Library, Western History Collection.*

with unbridled exuberance in the 1964 film. The real Mrs. Brown was a larger woman in every way, less musically inclined and considerably more complex than the fictional caricature loosely based on her life.

One of six children born to Irish Catholic parents in Hannibal, Missouri, young Maggie followed her older sister and brother to Leadville at the peak of the silver boom that transformed the two-mile-high community into Colorado's second-largest city almost overnight. She aimed to marry a rich

man and rise above the humble, uneducated beginnings of which she was always painfully conscious. Her plans were derailed by her passions when she met handsome James Joseph (J.J.) Brown at a church picnic and fell head over heels in love. The two were wed, and soon their happy family grew to include little Lawrence and Helen.

J.J. made a good living as a mine manager. But when he decided to look for gold where other prospectors sought silver exclusively, the Little Jonny Mine rewarded him richly. With this dramatic change of fortune, the Browns' lives would never be the same.

They moved to Denver and purchased an imposing mansion on Pennsylvania Street (now a house museum operated by Historic Denver, Inc.). The newly rich Margaret had two goals: first, to educate herself through tutelage and travel; and second, to join the rarefied ranks of Denver's "Sacred Thirty-Six," as the upper crust of local society was known at the time. Unfortunately for Mrs. Brown, the undisputed queen of Denver high society was not about to allow the lowborn, unsophisticated upstart into her exclusive circle. Mrs. Crawford Hill joined local gossip columnist Polly Pry in publicly mocking Maggie's rough edges and lack of refinement. It had to hurt.

Undaunted, Margaret made every effort to improve herself. She became fluent in five languages. She traveled throughout Europe and northern Africa. She made friends with fellow millionaires from places other than Denver. She was traveling in Egypt with the John Jacob Astors in April 1912 when she received word that her grandson was desperately ill. She hastened to Europe and booked the first ship bound for the United States—the White Star Line's *Titanic.* No one could have predicted that the state-of-the-art juggernaut was headed for disaster. But a North Atlantic iceberg proved that nature was ultimately in charge.

As the ship went down, Margaret Brown boarded lifeboat Number 6 only when forced to do so. Mrs. Brown's heroism amounted to more than sharing her furs with other women in the lifeboat and encouraging them to row to keep warm. Her most conspicuously noble actions came after the survivors were rescued by the *Carpathia.* Her heart went out to the third-class widows and orphans, desperate immigrants left to fend for themselves in a new country. She employed her foreign language skills to comfort and console them.

Before they even reached New York City, the Survivors Committee she organized on board the *Carpathia* had raised more than $10,000 to pay medical expenses for the injured and burial costs for those who succumbed after the

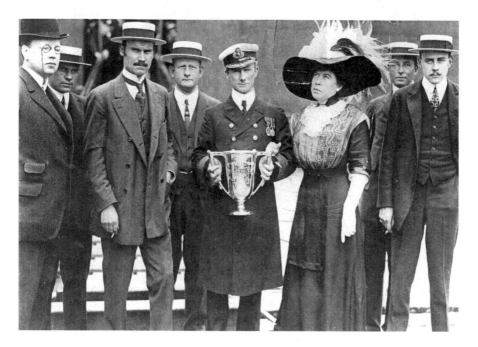

Margaret Brown presents a loving cup in appreciation to the *Carpathia* captain.

rescue. Margaret used her personal resources to help steerage-class survivors find family and jobs and to get them on their feet. This work kept her in New York City for more than a month before she returned to Denver.

The city welcomed her as a heroine of the disaster. Though frankly befuddled by the unexpected accolades, she kept her sense of humor and perspective. From her suite at the Brown Palace, she wrote to daughter Helen: "After being brined, salted, and pickled in mid-ocean, I am now high and dry." Asked by reporters how she managed to survive the ordeal, she declared, "It's the Brown luck. I'm unsinkable!"

Divergent interests pulled Margaret and J.J. apart. They separated in 1909. Both devout Roman Catholics, they never divorced—but they never reconciled, either. J.J. moved to the Southwest for his health. Margaret rented out their home on Capitol Hill and made trendy Newport, Rhode Island, her second home for most of the year.

When visiting Denver during this period, Mrs. Brown always stayed at the Brown Palace. Suite 629 was generally reserved for her. On one extended visit, she took voice lessons in the hotel. Ear-witnesses reported that her caterwauling could be heard up and down the eight-story atrium. She also

had a reputation of being the most energetic dancer on the floor in the Brown's Casanova Room.

Margaret held numerous fundraisers at the hotel for her favorite causes, including the Humane Society and Catholic charities. She championed labor reform, juvenile justice, historic preservation and women's suffrage. Colorado women were among the first in the country to win the vote in 1893, but the national campaign continued for another twenty-seven years. The progressive Mrs. Brown even made an unsuccessful bid for Congress in 1913.

Such a regular Brown Palace guest was Margaret that for many years she purchased and decorated a small Christmas tree for the hotel's front desk. Just before the holiday, she personally handed out gifts to every bellman, doorman, server and maid. Despite her obvious generosity and good heart, many hotel employees were a little afraid of the formidable Mrs. Brown. In her later years, she carried a brass-headed swagger stick, which she did not hesitate to employ when displeased.

In 1900, the Brown Palace threw a holiday party for underprivileged children, hosted by Margaret and fellow millionaire Benjamin Guggenheim. They provided a full holiday banquet and toy fair for 1,500 wide-eyed urchins. In a letter to the *Denver Times* editor, Margaret made no mention of her own generous contribution to the affair. "This year Denver is going deep into its pockets to provide a merry Christmas for everyone in the city," she wrote. "What pleasure it is to see the dear little children of the city so boisterously happy!"

Margaret Brown's greatest joy came always from sharing with the less fortunate and fighting for the overlooked. She was never comfortable with the heroine label, as she had only done what she considered right and natural. "I found many opportunities to be useful, and I was glad to be," she once told interviewers at a Brown Palace press conference. "The less you think of yourself...the better off you are."

KITTIE WILKINS: THE QUEEN OF DIAMONDS

She was the only woman in late nineteenth-century America whose sole livelihood was horse trading. Refined and ladylike, Katherine Caroline Wilkins surprised new clients expecting an uncouth Calamity Jane–type. She never failed to impress with her manners and her beauty, nor with her business acumen and quality livestock. Ambitious, successful and independent, "Kittie"

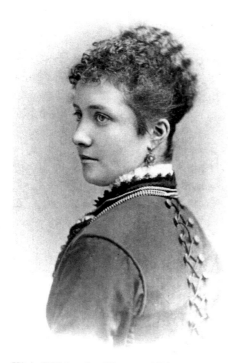

Kittie Wilkins, the "Queen of Diamonds."
Courtesy Owyhee County Historical Museum and Library, Mildretta Dadams Collection.

Wilkins was one of the best-known western women of her generation. Local newspapers headlined her arrival at every stop on her annual itinerary. That included Denver, where she stayed, on at least one occasion, at the Brown.

Mountain Home, Idaho, claims her, as it was from there that Wilkins shipped her horses. But Owyhee County in the southwestern corner of the state was Kittie's home and base of operations. On the vast Wilkins ranchland, as many as ten thousand horses might be ranging at any given time. Kittie's equine enterprise was known internationally as a reliable source for exceptional horseflesh. She was called the "Queen of Diamonds" because of the Wilkinses' famous diamond brand.

Kittie's parents came west along the Oregon Trail. Her father tried his hand as a shopkeeper, hotel proprietor and livery table owner in one mining camp after another but ultimately realized that raising and trading horses might be the real gold mine. He built their herd with money from his wife's inheritance, and it was she who controlled the finances. As a young adult, Kittie accompanied her father to horse sales and developed a keen eye for superior stock. He considered her horse trading savvy superior to his own. Kittie took the reigns of Wilkins Horse Co. in her thirties, becoming the public face of the company.

Miss Wilkins was a walking contradiction. On the one hand, she was a model Victorian lady, educated at a private academy, impeccably dressed, articulate and charming and musically accomplished. Her piano was her most prized possession, a tangible expression of her sophistication. She once told a reporter, "Next to petting my favorite horses, I like nothing better than to sit down at my piano and let my fingers drift along the keys." Ever mindful of propriety, Kittie even rode sidesaddle when rounding up horses!

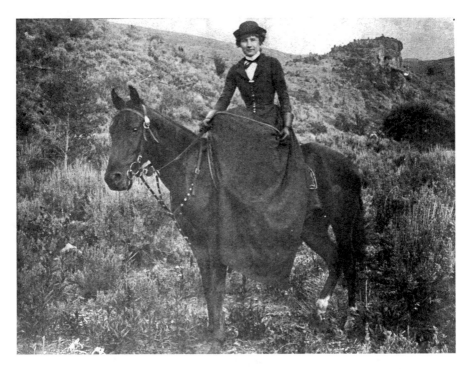

The "Queen of Diamonds" riding sidesaddle. *Courtesy Mountain Home Historical Museum.*

On the other hand, typical Victorian ladies did not usually pursue masculine professions. They did not know their way around a western horse ranch or urban stockyard, nor did they hold their own among powerful stockmen and big-time livestock dealers, as Kittie did.

Wilkins brokered perhaps the largest single horse trading transaction in U.S. history in 1900. To Erwin, Grant & Co. of Kansas City, she sold seven thousand to eight thousand animals, which it in turn sold to the British Crown for military mounts in the South African Boer War. The horses were shipped more than five hundred at a time from Mountain Home in twenty-car trainloads every two weeks until the total order was filled.

A key commercial center of the American West, Denver was always the first stop on Kittie's annual trading junkets. The Brown Palace was a favorite rendezvous for stockmen and the ideal place to do business. In September 1902, she arranged for a shipment of Clydesdales to a local buyer.

If media coverage is a barometer of fame, Wilkins was quite a celebrity in her day. Everywhere she went along the Union Pacific railroad line—San

The Brown Palace Club.

Francisco, Salt Lake City, Denver, Omaha, Kansas City, St. Louis, Chicago and New Orleans—Kittie Wilkins was big news. In a September 18, 1902 *Denver Post* interview at the Brown Palace, she left no doubt about her hatred of the newfangled "horseless carriages," which threatened not only her livelihood but also the bond of trust between human and animal:

I don't like them [automobiles]. *They are ugly, and they are unsafe. Look at the accidents that are always happening. Now, behind horses that you know and who know you—and if you and your horses don't understand each other, you should part company at once—there isn't the slightest particle of danger. Nothing serious can happen. Your horses are as ready for an emergency as you are, and will help you meet it.*

Bicycles, too, were anathema to Kittie. She thought it indecent for women to have to ride astride the contraptions and considered split skirts most immodest.

As a female horse trader, Kittie was one of a kind, but as a woman in the livestock business, she was not unique. By the early 1880s, more than eight hundred Colorado ranches were owned and run by women. A writer for the *Denver Republican* declared of the state's stockwomen in general: "They are all well and favorably known...They are worth several million dollars, and they have got the clearest heads and the best judgments as regarding stock."

Kittie Wilkins never married, despite many earnest proposals of matrimony. Rumors of a romance between her and her foreman, Joseph Pellessier, in 1909 were tragically silenced when the man was murdered by a sheepherder in a stereotypical western range war fight over water rights.

The Brown Palace's room 234 where Kittie Wilkins stayed is no more. The second floor of the hotel is now entirely devoted to meeting and office space. The guest chamber was long ago absorbed into the Brown Palace Club, occupying one of the hotel's forty-five-degree corners. From 1963 until April 2010, the space housed an exclusive dining club, where members could impress business associates with a private lunch or dinner.

When it debuted, the club was for gentlemen only, "to escape the giggling and gossip of women," one newspaper explained at the time. But in the liberated 1970s, a small cadre of determined feminists and masculine coconspirators compromised the all-male bastion with a brazen "sit-in." It was not long afterward that the chauvinistic policy was quietly abandoned. The independent spirit of Kittie Wilkins, were it still hovering in the vicinity, would surely have applauded the overdue recognition of businesswomen's basic equality.

EMILY GRIFFITH: OPPORTUNITY'S CHAMPION

When she moved to Denver in 1894, visionary educator Emily Griffith recognized a huge disconnect. In the city's poorest neighborhoods, many of her students missed classes because they had to work to help support their families. Their uneducated, unskilled parents were stuck in low-paying, demoralizing jobs—if they could find employment at all. At the same time, Denver employers were desperate for trained and competent help. By finding a way to fill the needs of both sectors of the population, Miss Griffith created a more productive citizenry and improved the lives of thousands of individuals.

Emily's teaching career began at the age of sixteen, when she taught in a one-room prairie schoolhouse to help support her family while her parents worked to "prove up" their Nebraska homestead. After completing Denver Public Schools' "normal" training, Miss Griffith taught sixth grade and later eighth grade classes in some of Denver's most ethnically diverse and most depressed neighborhoods. She began to offer, on her own time in the evenings, classes for working children and for their parents. Miss Emily knew that education was the key to escaping the downward spiral in which so many people found themselves trapped.

The goal of public education, Griffith always believed, ought to be to "fit folks for life." To her way of thinking, learning should not be limited to children but rather should be a lifelong process that included vocational training.

Years of gentle crusading—rallying the support of local businessmen's groups, women's clubs, social workers and charitable organizations—eventually paid off. Emily's "Opportunity School" idea was given the green light by the Denver Public School Board in 1916. Miss Griffith was appointed principal, with an annual salary of $1,800. The school board designated a condemned building to house the unorthodox experiment, doubting that it would ever amount to anything.

The school was open ten hours a day and five days a week so that working students could attend for an hour or two, whenever it fit into their schedules. Instruction was individualized, with each person progressing at his or her own rate. It was not a place for rigid teachers. With no age requirements, no admissions requirements and no attendance requirements, the concept was a radical one. As a public school, Opportunity was free to any city resident. People who enrolled were not told what classes they had to take but instead were asked what the school might offer them to make their lives and their employment prospects brighter.

Teaching basic reading, writing and math skills to adults, as well as English for the foreign-born and a full range of job skills, Opportunity was the first public school of its kind in the world. Denver immigration officials sent all new arrivals straight to Opportunity to learn not only how to speak the language but also how to navigate American society and to study for citizenship. Vocational courses prepared students for careers in everything from masonry and welding to telegraphy and millinery. Opportunity was one of the first schools in the nation to offer courses in auto mechanics and women's hairstyling.

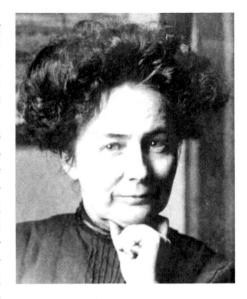

Emily Griffith. *Courtesy Emily Griffith Opportunity School.*

Working closely with the Denver business community was key to the school's success. Local employers coordinated with Opportunity to offer apprenticeships and hands-on training in many fields. Denver's hospitality industry partnered with Miss Griffith's school, placing hundreds of Opportunity graduates in hotel housekeeping, food preparation, maintenance and customer service positions. Classes in floral arranging, professional baking and cooking, carpentry, plumbing, heating and air conditioning, upholstery and janitorial and domestic services supplied the Brown Palace and other downtown hotels with well-trained, highly motivated staff.

Not everyone supported Opportunity's work. In the wake of the 1915 silent film *The Birth of a Nation*, portraying the Ku Klux Klan as the saviors of the post–Civil War South, many Americans felt justified in intimidating and segregating "negroes." The early 1920s also saw suspicion and resentment aimed at immigrants, whom some feared were taking jobs, instigating crime and degrading the American way of life. Racial and ethnic intolerance grew.

The "Denver Doers Club," organized by visiting Klan Imperial Wizard William Joseph Simmons and a select group of local men at a meeting in the Brown Palace in 1921, quickly evolved into the Colorado KKK. Its ranks swelled, and by 1924, the mayor of Denver, the governor and one of Colorado's U.S. senators were all loyal Klan members. KKK

representatives dominated both the state House and Senate, and klansmen controlled local police forces and city governments.

Even in the toxic atmosphere of **KKK** influence, Opportunity continued to empower Denver's racial minorities and immigrants through education. Countless women, too, found new confidence and new independence, thanks to Griffith's extraordinary courage, compassion and commitment to the equality and dignity of all people, regardless of their background or circumstances.

Emily's revolutionary idea changed lives and uplifted the entire community. Her vision and accomplishments brought her international fame. Much in demand as an inspirational speaker, Miss Griffith was the featured attraction on several occasions at the Brown Palace. In 1925, she was nominated for the prestigious Woodrow Wilson Award and spoke at the banquet held on December 28. Four years later, Emily was listed as speaker for the Roosevelt Day Dinner Banquet held at the Brown. Long after her retirement, Miss Griffith officially launched the 1945 annual Red Cross fund drive in the Brown's presidential suite—"the last place anyone would expect to find me!" she remarked to the society columnist who interviewed her.

Often overlooked was Emily Griffith's playful sense of humor. Quite aside from her nobler endeavors, Miss Emily was a 1909 founding mother of the Denver School Dames. As the name suggests, this teachers' group was less than prim. Outside of the classroom, they knew how to have fun. Over the years, they met for luncheons and camaraderie in various fine downtown hotels. But all agreed that there was only one place fitting for the occasion of their inaugural meeting: the Brown Palace.

Ordering a cocktail upon arriving at a School Dames luncheon was practically obligatory. Ordering a second was a dreadful *faux pas*. The business of the club was perfunctory. Typical meeting minutes read: "We met, we et, we bet we had the best time yet!" The club's constitution preamble made clear its mission:

> *We, the snatchers of the young from the depths of ignorance, in order to form a more perfect union, establish ourselves as an influence in affairs of general interest, promote the welfare of the teaching body, provide a party at least once in two months, secure the blessings of a few occasions free from masculine society, and give opportunities to discuss subjects pedagogical and frivolous, to display our good clothes and to show our latent abilities, do hereby ordain and establish this Constitution of the School Dames.*

Opportunity School teachers. *Courtesy Emily Griffith Opportunity School.*

On February 28, 2009, the Denver School Dames celebrated the 100th anniversary of its founding with a luncheon in the Brown Palace. Members displayed old photos, postcards and other ephemera from a century ago. They asked to borrow a guest register from the hotel archives to exhibit at the event, as well. To everyone's surprise, one of the pages for February 28, 1909, included the signature of "H.R.H. Prince of Wales." A little research revealed that the original Dames had shared the Brown that day with the future King George V of Great Britain!

Naughty Neighbors: The Notorious Navarre

Lovers of historical architecture and urban curiosities speculate endlessly about the classical building with the dome-shaped cupola across Tremont Street from the Brown Palace. What was it? What is it? Can its past be as racy as the rumors?

Designed by the same architect as the Brown, it was the third Frank Edbrooke building of seventy-three contributions to the Denver cityscape.

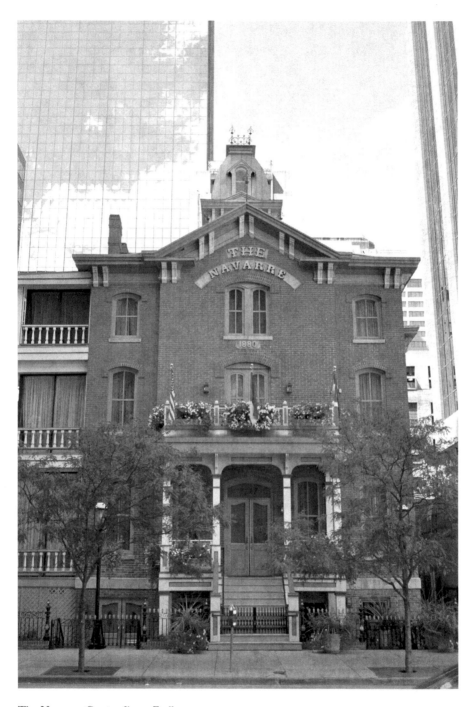

The Navarre. *Courtesy James Faulkner.*

Legendary Ladies

Opened in 1880 as Brinker's Collegiate Institute, a boarding school for refined and musically inclined young ladies, it had to be sold when Mr. Brinker passed away. Subsequent owners transformed it into the Richelieu Hotel, a questionable establishment with gambling in its basement. Apparently the Richelieu owners succumbed to the heady allure of risk-taking themselves, because it wasn't long before they lost the building in a poker game to a pair of Denver's underworld figures.

It was these nefarious gentlemen who gave the place its current name, the Navarre, after Henry of Navarre, a *bon vivant* French monarch who enjoyed wine, women and song. As things developed, this turned out to be a very appropriate name for the new owners' enterprise. The Navarre was reopened as—horror of horrors—a house of ill repute, a brothel, a most shameful blemish on the Brown Palace/Trinity Methodist neighborhood. Twenty years after its respectable origin, the Navarre began boarding quite a different sort of young ladies, whose special talents went decidedly beyond the musical.

From this period, in the early 1900s, arose the rumors, the legends—or perhaps the memories—of a tunnel that once ran from the basement in the front part of the Navarre under Tremont Street to the basement of the Brown Palace. The area directly across from the Navarre, where stand today's escalators and Ship Tavern Landing, was originally the Gentlemen's Smoking Club. How discreetly convenient it would have been to disappear into the basement below the club and over to the Navarre—without being spotted by all the snoopy Trinity Methodists!

Disappointingly, there is no tunnel connecting the Navarre and the Brown today. There is, however, an intriguing indentation in the Brown's basement wall exactly opposite the former brothel, likely the remnant of such a passageway, emerging near the huge boiler. This hypothetical tunnel could have served other illicit purposes, such as a convenient place to color bootlegged gin to resemble tea in order to serve it in delicate china pots to unsuspecting—or complicit—ladies in the hotel lounge.

Early Denver was notorious for its bawdyhouses, most of which did business on Market Street. Though the city officially outlawed prostitution in 1913, the ban was but loosely enforced until the appointment of Denver's first policewoman, Josephine Roche. An earnest Vassar girl with a degree in social work, Miss Roche took her job as "Inspector of Amusements" most seriously—too seriously for the tastes of corrupt officials and high-powered businessmen who appreciated the temporary but blissful distraction only "soiled doves" could provide.

Left: Neighboring Trinity Methodist Church at the corner of Broadway and Tremont Street. *Courtesy James Faulkner*

Below: *The Sultan's Dream*, 1892 painting by Virgilio Tojetti depicting a male sensual fantasy, hangs presently in the hotel's Churchill Cigar Bar.

Roche understood the exploitive side of prostitution, which often victimized young women who had run out of options and into trouble. High rates of drug abuse, suicide and murder among these "brides of the multitudes" bespoke volumes about the dehumanization and vulnerability of those plying the world's oldest profession. Roche made it her mission to shut down the city's parlor houses and cribs. She rescued many of their employees and set them on the path to self-respecting careers.

The Navarre's sleazy days are far behind it now. Subsequent incarnations transformed the building, at various times, into dining and drinking establishments and, later, a museum. Local billionaire Phillip Anschutz acquired the building in 1997 and made it his private art collection gallery. The original Remingtons, Russells, Bierstadts, Catlins, Morans and O'Keefes that cover the Navarre's three-story atrium are not accessible to the general public.

Some believe that restless spirits of shady ladies from the Navarre's bawdy heyday occasionally drift across the street to visit gentlemen sleeping alone in rooms on the Tremont side of the Brown Palace. At least one guest admitted seeing a scantily clad, transparent young woman hovering over his bed, enticing and inviting him to slip across the street for a good time. Spectral solicitors obviously require no tunnels.

Part II

Society Ladies

MRS. CRAWFORD HILL:
DOYENNE OF THE "SACRED THIRTY-SIX"

Memphis belle Louise Bethel Sneed was many things—aristocratic, glamorous, vivacious, ambitious and uncompromising. But at age thirty-two, she was no ingénue. Prosperous bachelors were as scarce as hen's teeth in the post–Civil War South, and Louise was determined to make a good match before her best days were behind her. Tempting tales of fresh new fortunes wafted out of the West and drew her like a fly to honey. Arriving in Denver, she snagged the most eligible local bachelor, and that was only the beginning for Louise. The presumptuous cow town was about to get its first real taste of social snobbery from a consummate expert in exclusivity.

Never mind that the 1893 Silver Crash had devastated the Colorado economy. Most of Colorado's true tycoons—whose diversified portfolios were not based solely on mining—weathered the recession scarcely diminished. Surely a well-bred and beautiful southern lady could find many wealthy candidates from whom to choose in the financial hub of the Rocky Mountain Empire.

A welcoming ball in Louise's honor was held in Bethel Castle, her cousin's mansion atop Capitol Hill. Denver's elite "Old Guard" was little more than a generation removed from the city's frontier boomtown days. The *nouveau riche* had acquired fine homes and furnishings, fancy clothes and gaudy jewelry. But they could not buy the impeccable etiquette or air of superiority that "old money" families like Louise's had mastered long ago. Miss Sneed

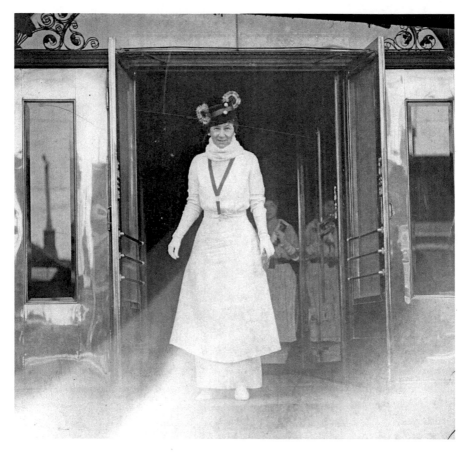

Louise Sneed Hill leaving the Brown Palace. *Courtesy Denver Public Library, Western History Collection.*

disdainfully pronounced the city "a social wasteland." Like some exotic fish in a stagnant pond, Louise made quite a splash.

She also made an enviable catch in the form of Crawford Hill, son of millionaire Nathaniel P. Hill. Hill the elder, a chemistry professor from Brown University, had almost single-handedly saved the floundering Colorado gold industry by building the future state's first smelter. Prior to his innovation, ore had to be shipped all the way to Swansea, Wales, for final extraction, a prohibitively costly arrangement. Professor Hill's Black Hawk, Alma and Argo smelters made gold mining in Colorado significantly more profitable and attractive to investors. As a result, Hill became not only a very wealthy man but also Colorado's first Republican U.S. senator.

Crawford, it seems, had inherited none of his father's dynamic vision or initiative. He did, however, inherit a privileged lifestyle and a taste for the finer things. Louise Sneed was one of the finest things he had ever seen. Decidedly dull, but otherwise unobjectionable, the smelter heir apparent suited Louise's purposes nicely. In 1895, she became Mrs. Crawford Hill. Crawford's mother resented Louise's obvious money grab. His sisters resented her social competition. But along with the rest of Denver's upper crust, the Hill women soon came to recognize that they were no match for the new queen on the scene.

The newlyweds' first home was made in apartments acquired by Augusta Tabor in her divorce. Louise thought their rooms dark and cramped, woefully inadequate for the lavish entertaining she had in mind. Upon producing their two sons, Nathaniel and Crawford Jr., Louise's every wish was her obliging husband's command. He soon installed her in a stately twenty-two-room neoclassical mansion at 969 Sherman Street. At last she had a home as grand as her social ambitions.

Mrs. Crawford Hill taught Denver's top tier how to party in style. She filled her mansion with flowers and music. She dressed in haute couture and high heels and swept down her elegantly curved staircase in conversation-stopping entrances. It was nothing but the best for Louise—the best orchestra, the best caterers and all the best people. Designating those select elite became Mrs. Crawford Hill's life's work and her most enduring contribution to Denver society.

It began with the "Sacred Thirty-Six." The name referred to the number of people required to fill the tables at exclusive bridge parties, dubbed "sacred" by a Denver newspaper reporter to denote their loftiness. It was into this cliquish group that Mrs. J.J. Brown sought acceptance when she moved to Denver's Capitol Hill. As arbiter of the city's aristocracy, Mrs. Crawford Hill was not about to allow a rough-edged upstart with boisterous manners and improper grammar to sully the "Sacred Thirty-Six." Not one to be impressed by charitable acts of selfless philanthropy, Louise held fast to her lockout of Mrs. Brown until the *Titanic* disaster and its aftermath made the "Unsinkable Molly" a national heroine. Then the doors to the Hill mansion flew open, and the former outcast was welcomed as another excuse for Louise to pop open the champagne.

By 1908, Mrs. Hill was dictating the first *Who's Who in Denver* to her private secretary. It listed more than two thousand names of the city's *crème de la crème* under classifications including "Worth Over a Million," "The Smart Set" and "Types of Denver Beauty," the latter category created especially

for Mrs. Hill herself to dominate. The criteria for inclusion in the directory were simple. "First, you must have money," she once explained. "Then, you have to know how to entertain." That first social register evolved into today's *Blue Book*, still the definitive encyclopedia of well-heeled Denverites.

Mrs. Crawford Hill traveled frequently to Newport, New York, London and Paris. Through a friend in the diplomatic corps, she arranged to be presented at the court of King Edward VII. Her satin gown for the occasion was embroidered with diamonds, and her red velvet cape was trimmed in fourteen-karat gold. Denver reporter Polly Pry gushed that "Mrs. Crawford Hill is one of those rare beauties to whom no photo can do justice." Of course, it didn't hurt that Louise blatantly bribed writers to feature her and her parties on the society pages.

When she wasn't traveling or entertaining, Mrs. Hill was lunching at the Denver Country Club or watching Sunday polo matches. It was at one such polo match that a particularly dashing player caught her eye. Bulkeley Wells was president of the Smuggler-Union gold mine, brigadier general in the Colorado National Guard…and the married father of four. He was also substantially younger than Louise, in her fifties at the time.

Louise was not a bit discreet about their love affair. She went so far as to hang a life-sized portrait of the handsome Mr. Wells in the foyer of their mansion, right along with Crawford's smaller likeness. The affable Mr. Hill was either oblivious or ambivalent to his wife's extramarital dalliance. In fact, all three of them often went to dinner or on outings together.

When Crawford died in 1923, Louise, then sixty-one, fully expected the now divorced Bulkeley to propose marriage. He did—but not to her. He had the unmitigated gall to elope with a young, blonde divorcée. Louise did not take rejection lightly. She vowed to ruin him financially. She persuaded rich and powerful friends to withdraw their support of his ventures, and Bulkeley soon found himself facing inevitable bankruptcy. Destitute and despondent, he committed suicide with a bullet to his brain. The remorseless Louise commented blithely, when asked what had become of her former paramour, "Well, I really don't know."

The Capitol Hill mansion and the endless round of parties finally got to be too much for the aging Mrs. Hill. She stored her furs and spent the last fifteen years of her life in one of the tony Skyline Apartments on the top floor of the Brown Palace, along with a small staff and many of her old friends, including the Boettchers and the Blackmers. In her waning days, senility took its toll, and she saw almost no one. She succumbed to pneumonia in her Brown Palace suite in 1955. She was ninety-one, but

Brown Palace switchboard operators, 1957.

like any proper lady, she had never discussed her age. "I was born in North Carolina," she once explained, "where a girl becomes sixteen when she is about twelve or fourteen. She stays sixteen until she's twenty-one, and she remains twenty-one until she's thirty. Finally she's eighty-five and she tells everyone she's a hundred."

Some believe that Mrs. Crawford Hill's haughty spirit somehow survives within the Brown Palace. In February 2000, hotel historian Julia Kanellos developed Valentine-themed tours entitled "Affairs of the Heart." The stories of romance and scandal included the tryst between early "cougar" Mrs. Hill and Bulkeley Wells.

Curiously, at the exact times that Julia was conducting these tours, the hotel switchboard began to receive calls from room 904, Mrs. Hill's former apartment. The operators who picked up the line heard nothing but static on the other end. After several instances of the tours and the phone calls coinciding, Julia put two and two together. Perhaps Louise didn't want her personal dirty laundry aired before the general public. Julia dropped Mrs. Hill's story from the tour, and the phone calls immediately ceased.

What makes the episode especially puzzling is that all of this took place during a major remodel of the top two floors of the hotel. Every room was completely stripped of not only furnishings, carpets and light fixtures but also telephones. There was not a phone to be found on the eighth or ninth floors when the persistent calls apparently attracted the desired attention. Whatever the explanation, tours that show room 904 today depart, just in case, with a respectful "Thank you, Louise."

ISABEL "SASSY" SPRINGER: PLAYING WITH FIRE

In May 1911, young and achingly beautiful Isabel Patterson Springer found herself juggling the attentions of two ardent admirers. Dashing daredevil and wine salesman Louis "Tony" Von Phul had just hastened from St. Louis at her behest. Frank Henwood had in recent months become increasingly possessive and protective. Moreover, there was the little matter of her husband, wealthy banker and rancher John Springer, twenty years her senior, who knew nothing of her romantic indiscretions. What was a girl to do? Isabel's inability to manage the volatile dynamics she had set in motion led to the first—and most scandalous—murder at the Brown Palace.

The Springers had both a seven-bedroom Denver mansion on Washington Street and "Castle Isabel" on their Cross Country Ranch, where today's Highlands Ranch suburb dominates Douglas County. But John found it more convenient to take a chamber at the Brown while conducting business downtown. His trophy wife "Sassy" (as she was known to her many male admirers) whiled away the tedious days shopping, flirting and drinking too much. On this particular occasion, she suspected that she had gotten in over her head. Her impassioned letters to Von Phul had the desired result of bringing him to Denver, but the timing was suddenly all wrong. She knew that Tony and the jealous Frank had quarreled in the hotel dining room the night Von Phul arrived. Languishing in suite 600 and sensing that everything was about to unravel, Sassy decided to put all her eggs in the Henwood basket, knowing that he would be all too eager to rescue her.

She told Frank that things had gone sour with Tony and pleaded with him to go to Tony's room at the Brown to demand the return of her love letters, which she feared that, once spurned, Tony would use to blackmail her and sabotage her marriage. Henwood, comfortably ensconced in room

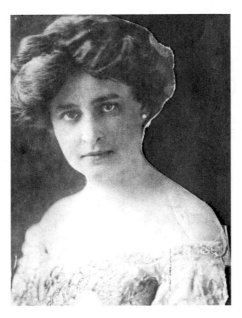

Isabel "Sassy" Springer. *Courtesy History Colorado.*

715, just up the Grand Staircase from Sassy's rooms, then dutifully pounded on the door of Von Phul's room, 404.

When Frank tried to make Tony see reason and turn over the damning correspondence, Tony not only refused but also went so far as to pull a gun on Frank and order him out of his room. The plot thickened.

Time passed, and all parties involved in the volatile quadrangle went to dinner and then to the theatre on the night of May 24. Following the shows, Frank and Tony inevitably encountered each other in a Brown Palace bar that no longer exists. Original Edbrooke blueprints housed in the hotel's archives indicate that it stood in the space now occupied by the Ship Tavern Landing, a sitting area at the base of the escalators.

Macho posturing naturally ensued. In the physical climax of the verbal confrontation, Tony pushed Frank to the floor of the bar and appeared to reach inside his vest. Frank assumed that he was going for a gun, as he had done earlier that day. So Frank pulled out a pistol he had purchased just hours earlier. He had never fired a gun in his life, and he began shooting wildly.

Frank hit an innocent bystander and mortally wounded him. He hit another collateral victim and shattered the man's femur. He finally fired a shot that found his intended mark, but he did such a botched job that Tony shrugged off the bullet wound with characteristic bravado. He calmly walked to the adjacent Gentleman's Smoking Lounge and collapsed in a chair. Only later did he allow someone to take him to the hospital, where he died of his injuries almost exactly twelve hours later.

During the shooting spree, Brown Palace elevator operator Frank Canfield showed courage under fire by grabbing the gun from Henwood. Bartender Frank Miller promptly tucked the murder weapon into a drawer until police arrived. No one could ever really say whether Von Phul had a weapon concealed inside his vest.

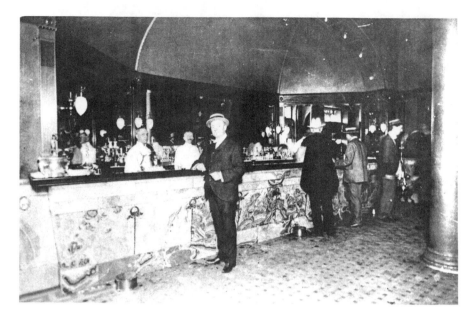

Marble Bar, where the 1911 murder took place.

The ensuing trial was a sensational media circus locally. Not only were Sassy's infidelities exposed but also her alcoholism and drug addiction. The cuckolded John Springer, of course, dropped her like a hot potato. After the trial, the disgraced Isabel went to New York City to "model." But because of her myriad self-destructive habits, she was overweight and white-haired before she was thirty-five—and dead before she reached forty.

Frank Henwood's plea of self-defense never stood up, and he was sentenced to life in the federal penitentiary in Canon City. He died there eighteen years later.

The dust settled; the ordered life of the Brown returned to normal. And nobody involved in the crime lived happily ever after.

Tragically, the venerable hotel was the scene of yet another murder on September 30, 1946. Ronald Smith, World War II veteran and Grand Junction police officer, began drinking in the Ship Tavern early that afternoon. By evening, he was three sheets to the wind. Someone at the bar said something that rubbed him the wrong way, and the next thing anyone knew he was firing blindly about the room. One bullet hit and injured the president of Colorado Agricultural College (now Colorado State University). Another wounded a visiting advertising man. A third fatally felled a young doctor, James Mason, recently arrived from Idaho. It took three Lowry

Airfield men to wrestle Smith to the floor and end his murderous rampage. He, like Henwood, concluded his life in the federal pen.

While researching his 2003 book *Murder at the Brown Palace*, local writer Dick Kreck discovered that Sassy Springer slumbered eternally in an unmarked New Jersey grave. Kreck and his Fulcrum Press publisher, Bob Baron, felt compelled to rectify the situation. The two split the cost of a simple granite marker for the hapless *femme fatale*, whose ability to captivate men evidently endures a century later.

Evalyn Walsh McLean: The Last Hope

Evalyn Walsh's first memory was of a cold, half-dark, two-room log cabin, high in the mountains near Leadville. Her father, Irish immigrant prospector Thomas Walsh, tried his luck in more towns than little Evie could remember before the Camp Bird gold mine in Ouray, Colorado, made him a multimillionaire. From then on, the Walsh family embraced the posh life.

They moved to Washington, D.C., as all the fabulously wealthy were wont to do in the day, and threw sumptuous parties in their Second Empire–style mansion (now the Indonesian Embassy). Evalyn was required to transform herself from tomboy to debutante in short order. She was packed off to Paris to study music, French and "other parlor tricks of ladies," she wrote in her memoir, *Father Struck It Rich*. "By some school magic, I was to become a lady!"

Instead, what Evalyn Walsh became in Paris was a power shopper extraordinaire. She bought dresses by the shop-full and tried on new hairstyles like others donned hats. She returned from one European jaunt with an outrageously intricate do that made it impossible to wash her hair. When Evie's father asked what it would take to persuade her to go back to a more traditional coiffure, her answer was simple and direct: "Jewelry."

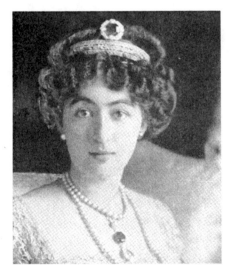

Evalyn Walsh McLean wearing the Hope Diamond.

Evalyn's passion for jewelry became legendary. She was the last private owner of the infamous Hope Diamond, purchased from Pierre Cartier in 1911 for $180,000. Her collection also came to include another famous diamond, the ninety-four-carat Star of the East.

The Walsh family returned to Colorado for summers at their Wolhurst estate. In the spring and autumn from 1906 to 1908, Evalyn and her mother lived at the Brown Palace while opening and closing their summer house.

Evie counted among her Washington friends President Teddy Roosevelt's daughter, Alice Roosevelt Longworth, and Florence Harding, wife of President Warren G. Harding. At age twenty-eight (though she claimed to be twenty-five), Evalyn Walsh eloped with handsome newspaper publishing heir Edward "Ned" Beale McLean. The McLeans had four children, buckets of money and a seemingly enviable life.

Evalyn never believed in the "curse" of the Hope Diamond, but she could not entirely discount the string of misfortunes visited upon her in the years after she acquired the storied jewel. Her husband, Ned, ran off with another woman and eventually died in a mental hospital The eldest of her four children, son Vinson, was killed in a car accident. Her only daughter, Emily, died of a sleeping pill overdose, leaving a four-year-old daughter, Mamie Spears Reynolds. The family newspaper, the *Washington Post*, went broke, and Evalyn herself fell victim to a con artist who talked her out of $100,000—allegedly to ransom the Lindbergh baby.

The tragic blows were attributable to nothing more than fate's vicissitudes, Evalyn would contend until the end of her life. Nothing could convince her to surrender the fabulous Hope Diamond. As she explained in the foreword to her memoir: "I had it blessed myself, and I am sitting back on the sidelines, letting the curse and the blessing fight it out together. Personally, I have so much faith in goodness and right working out in the end that it never worries me."

Evalyn flaunted her diamond tiara with the forty-five-carat gem in all the best places, including Denver's Brown Palace. She often stayed at the Brown in later years, while visiting old friends in Denver and attending opening night of the Central City Summer Opera Festival. The impetuous heiress was accustomed to having her every whim granted. In mid-July 1937, Mrs. McLean presented perhaps the biggest challenge ever faced by the famous hotel's banquet staff. The episode was later recalled by drama critic, historian and author Lucius Beebe in his autobiography *Snoot If You Must*.

It was a Sunday afternoon when Evalyn "took it into her head to give a dinner party of fantastic proportions that same evening at the Brown

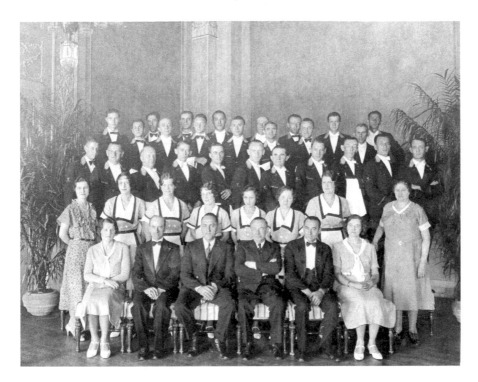

Brown Palace Banquet staff, circa 1930.

Palace Hotel…Six hours later, we sat down to a full-dress turnout, with two name bands, enormous ice elephants full of fresh caviar, quadruple bottles of Bollinger '26, roast Mexican quail, and the *crème de la crème d'Isigny* of Denver society."

"Only the Brown Palace and only Evie McLean could contrive such magnificence," Beebe concluded.

Like so much of the nation, Evalyn fell on hard times during the Great Depression, but she never let it diminish her dash. The Hope Diamond, along with her other jewels, were in and out of New York pawnshops throughout the 1930s. An older, wiser Mrs. McLean acknowledged her revised priorities in 1936: "Money is lovely to have and I have loved having it, but it does not really bring the big things in life—friends, health, respect—and it is so apt to make one soft and selfish. If I had only had the courage to lead my own life years ago, I might by now have helped so many poor souls, and might have done infinitely more good."

By the time she bowed out in 1947, Evalyn Walsh McLean's estate, including the fabulous jewels, was appraised at $919,500. In her will, she left

the Hope Diamond and the Star of the East in trust for her granddaughter Mamie until the girl turned twenty-five (in 1967). Nevertheless, just two years later, the Hope Diamond was sold to Harry Winston for more than $1 million. Perhaps fearing the so-called curse, Winston donated the infamous gem to the Smithsonian Institute, where it still glitters seductively on display, awaiting another heiress to take it out on the town.

JACQUELINE HOEFLER TROYER: PALATIAL PLAYGROUND

The Brown Palace has always made a big impression on little ladies, too. Young Jacqueline Hoefler lived with her mother and father in an eighth-floor suite for three years in the late 1920s and made the palatial hotel her personal playground.

Jacqueline's father, Paul Louis Hoefler, was an African explorer. A fellow with the Royal Geographic Society, Hoefler had already led one successful expedition from Denver in 1925–26. As he undertook preparations and sought funding for a second daring venture to the mysterious Dark Continent, Hoefler moved his wife and young daughter into the Brown Palace. The explorer's two principal financial backers, Horace Bennett and Charles Boettcher, had been co-owners of the hotel until recently, when Boettcher purchased cash-strapped Bennett's majority interest in the business. As a magnet for the rich and powerful, the Brown was an ideal base for generating money and interest in the Colorado African Expedition of 1928.

Hoefler's adventure, the first trans-African crossing successfully undertaken by motor truck, took his team through the heart of equatorial Africa. In addition to being an expert safari hunter, Hoefler was one of America's earliest cinematographers. The product of his ambitious journey, *Africa Speaks*, was the first full-length documentary film produced with sound. On the heels of its acclaim, Hoefler also penned a book of the same title while living at the Brown Palace. The book's dedication read: "To my beloved wife, who, by staying behind and believing in my ultimate triumph, made the undertaking possible and gave me the courage to press onward."

Young Jackie, who grew from age six to nine during these years, was blissfully unaware of the complicated logistics and sponsorships that her father had to arrange in mounting his expedition. She understood little

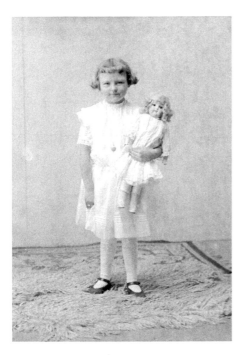

Left: Privileged young lady, circa 1925.
Courtesy History Colorado.

Below: Eighth-floor Grand Ballroom.

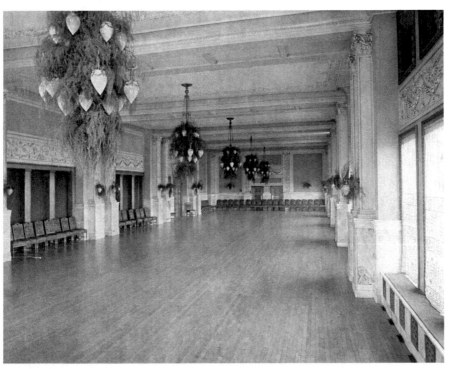

about the harrowing dangers he faced while away. What Jackie did know was how delightful living in the Brown Palace was for a curious and friendly youngster. "I reveled in the Hotel's vitality and the excitement of its various functions," she reminisced in a 1991 letter.

In the 1920s, much of the hotel's eighth floor was two stories high. The soaring Grand Ballroom, which occupied one of the triangular building's forty-five-degree corners, also served as a banquet hall for up to 350. Two-story private dining rooms faced the Rocky Mountains, and the Ladies Ordinary, a combination changing room and lounge for guests, occupied two stories in the other forty-five-degree corner.

The little girl, who obviously inherited her father's thirst for discovery, explored every nook and cranny of the fascinating building. Jackie was allowed complete freedom to come and go as she pleased, from the basement kitchens to the rooftop, where she walked her dog. Decades before the Brown adopted its pet-friendly policy, Jackie was granted special dispensation by management to keep her dog in the hotel. The 360-degree view from atop the nine-story building was entirely unobstructed at the time. The bustling Queen City of the Plains spread below her, with rolling prairies to the east and majestic mountains to the west.

A bit of a novelty at the Brown, the cheerful child made friends with other long-term guests. Her mother and Mrs. J.J. Brown, famous survivor of the *Titanic* disaster, struck up an acquaintance, and Jackie remembered the flamboyant woman fondly. The generous gift of a large chocolate Easter egg one year was never forgotten. Governor William H. Adams was another hotel resident of the little lady's acquaintance. Jacqueline sometimes walked to the nearby state capitol to visit his office. The governor let her sit on his desk and munch candy while he told her tales of his ranch and the Old West.

Jackie fell seriously ill on two occasions while living at the Brown Palace. While her father was away in Africa, she suffered an attack of acute appendicitis. The family doctor was summoned to their rooms, and she was rushed to the hospital for an emergency operation. Jackie enjoyed special attention from the hotel staff during her recuperation, and she remembered her mother rolling her around the balconies in her doll buggy during an otherwise monotonous convalescence.

Her father had returned and was writing his book when Jacqueline was diagnosed with scarlet fever. Highly contagious, the disease often led to serious complications in those days before antibiotics. A month-long quarantine was mandated in every case.

This dictate posed a serious dilemma for the hotel, which could not afford to shut down for such a long period. Jackie's parents, their family doctor and the Brown's management concocted a workable plan. The Hoefler suite was tucked into a corner opposite an elevator. An "Out of Order" sign effectively shut down the elevator, and the quarantine sign was posted inconspicuously around a corner, where the light was switched off. Staff members were sworn to absolute secrecy.

Not even her parents were allowed to visit the afflicted little girl. They moved into an adjacent room, while a full-time children's nurse took charge of the patient. All of their meals were sent up, and Jackie was ordered to spend the month in bed, with minimal movement only. She later recalled her wonderful nurse, who "not only took excellent care of me, but also entertained me every waking hour."

Jacqueline Hoefler's sojourn at the Brown concluded happily when her father decided to take her and her mother along on his 1931 Colorado Asiatic Expedition to India and beyond. Years later, Jackie donated many materials from her father's travels to the Denver Natural History Museum (now the Museum of Nature and Science) and the Lowie Museum of Anthropology at UC-Berkeley.

News of the Brown's 100th anniversary celebration in 1992 inspired the late Jacqueline Hoefler Troyer, then of Grand Junction, Colorado, to share her childhood reminiscences in a letter to Jane Andrade, the hotel's director of public relations. "One of the reasons that the Brown has survived for 100 years as a top quality hotel has been its excellent management and service," she concluded. "Its unusual architecture, which is so beautifully maintained, famous restaurants and colorful history appeal to anyone entering its doors. Need I say how much the Brown Palace Hotel means to me?"

MARIETTA VASCONCELLS BAKEWELL: SIR GALAHAD'S LADY

The founder and namesake of the Brown Palace Hotel was simply "Grandfather" to Marietta Cassell. Born in 1898 to Robert T. Cassell and Carrie Brown, Henry C. and Jane's daughter, Marietta, seemed to want for nothing. "I was dirt-spoiled as a youngster," she later admitted in an interview. Naughty Marietta soon veered from the straight-laced lifestyle of her prominent forebears and became a pioneer herself, significantly expanding the role of women in the media.

Marietta remembered the Denver of her childhood as a sleepy little town, where most folks still counted on horses and buggies. Marietta and her three brothers had ponies, kept in vacant lots near their Capitol Hill home. Her progressive parents, however, buzzed around in electric motorcars.

Her girlhood best friend was Gladys Bennett, daughter of Horace W. Bennett, who later owned the Brown Palace in partnership with Charles Boettcher. Another friend, Flora Lewis, came from the family that owned the prosperous Lewis & Son Department Store at Sixteenth and Stout Streets downtown. Marietta never forgot the adventure of motoring up to Estes Park with the Lewis family, a feat so unusual for the time that it made the papers. They spent the night there at the new Stanley Hotel, a pleasant enough place, Marietta supposed, but nothing to compare with Grandfather's Palace.

Like all proper Denver young ladies, Marietta Cassell attended the Wolcott School for Girls and Miss Hayden's ballroom dancing school, where she learned proper etiquette. Her teens were spent at boarding school in New York.

Marietta fell in love for the first time at eighteen with a young Army Medical Corps lieutenant, William Thomas Fitzsimons. Soon thereafter, she was seeing him off at Denver's Union Station, on his way to serve in the Great War overseas. She promised to wait for him faithfully until it was over "over there."

Lieutenant Fitzsimons never returned. He was killed by a bomb dropped on a military hospital, the first U.S. officer to die in France in World War I. Denver's Fitzsimons Army Medical Center is named in his honor.

Devastated and despondent, Marietta met Lafayette "Lafe" Franklin, a University of Colorado classmate of her youngest brother. On a whim, she eloped and married him—in Boulder, to avoid the Denver newspapers. It wasn't long before she regretted her impetuosity.

The Franklins moved to New York, but all was not well for the newlyweds. "I was soon to realize that my young husband had little to offer me off the bed," she recalled with characteristic candor. Their physical compatibility led inevitably to the birth of Marietta's first and only child, a son named Lafe after his father.

"I was not a good mother," Marietta confessed in retrospect. "As far as I was concerned, he was a nuisance." Recognizing her shortcomings and ambivalence toward motherhood, Marietta left her infant son with his paternal grandparents in the East when she divorced Franklin. She returned to Denver and resumed the unencumbered life of a young socialite.

One evening at a local drugstore hangout, Marietta's friends introduced her to dashing pilot Jerry Vasconcells, Colorado's only World War I flying ace. "Captain Jerry" was credited with shooting down five German pilots and walking away from many a wrecked plane unscathed. His whirlwind courtship of Marietta led to their wedding on October 18, 1922.

This time, Marietta got marriage right. The Vasconcells adored and delighted in each other. Jerry made a good living as a partner in a stockbrokerage firm and was able to support his wife in the pampered manner to which she was accustomed. Like characters in an F. Scott Fitzgerald novel, they roared through the affluent 1920s like there was no tomorrow. The minor inconvenience of Prohibition couldn't deprive them of their customary evening cocktails. Pilot friends of Jerry's flew contraband Scotch down from Canada, and he concocted bootleg brandy in their basement.

"Prohibition had made nice people lawbreakers," Marietta later declared, "and some, who otherwise might have remained social drinkers, alcoholics. It was smart to drink, and because you never knew when you might get more, you kept drinking until the bottle was killed."

Marietta was at the forefront of the national campaign to repeal Prohibition. Her crusade flew in the face of her grandmother, Martha Cassell, who had founded a temperance league instrumental in pressuring Colorado lawmakers to legislate Prohibition fully four years before the rest of the country.

The Vasconcells were among the first to toast the end of Prohibition in the Brown Palace's new Ship Tavern. "We did a great deal of partying in the old days," Marietta recalled as she pushed ninety. "We were young and healthy, and all our dear friends enjoyed the same things—the golf and the horseback riding and the dancing. We used to stay out all night long. I've always been a lawless person, I think...I had a rather shameful reputation of having a hollow leg."

Among Denver's classiest spots for nightclubbing during this time was the Casanova Room in the Brown Palace. With walls and ceiling draped in billowing silks, it resembled an exotic boudoir. The Brown Palace Orchestra played for dinner and dancing. When the Casanova Room was gutted by fire in 1935, it was soon replaced by the smart New Casanova Room—sans silks—and decorated with an Art Deco–style ceiling mural by well-known artist John E. Thompson.

When the 1929 Stock Market Crash brought the Vasconcells to the brink of financial ruin, Marietta decided to go to work at the *Rocky Mountain News* to help pay the bills. The managing editor hired her out of

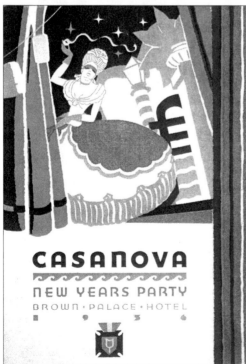

Above: Brown Palace employee Helen McLane climbs the Ship Tavern Crow's Nest, 1935. *Courtesy Lisa Michaels.*

Left: Casanova New Year's menu cover, 1935–36, designed by Hugh Weller.

respect for her husband's war exploits. The city editor had to cope with her. The only woman on the *Rocky* staff not assigned to the society page, Marietta set out to prove her moxie with stories of sensational crimes and women in prison.

"Marietta has crashed into the newspaper game with a bang," a magazine wrote of her at the time. "When she recently had her smiling photo blazened forth on the pages of a local paper in company with the Queen of City Jail…it proved somewhat of a shock to the more pretentious members of society. But then, Marietta is Marietta. Beauty and brains can get away with anything, it seems."

After a year with the *Rocky*, she took on a new challenge. KOA radio gave Marietta her own show, *The Human Interest Story Back of the Merchandise*, sponsored by and featuring Denver's May Company department store. Her radio career eventually spanned nearly twenty years.

In the 1940s, she parlayed her on-air experience into a public relations career, writing press releases and promotional materials for organizations including the Red Cross, the Dumb Friends League and the Central City Opera. Her first PR assignment, she later recalled, was also her most frustrating. She doggedly promoted Denver's Planned Parenthood in the days when the topic was strictly taboo. Neither of Denver's major newspapers would print her stories on the organization, despite the fact that all of the women involved were socially prominent. Marietta's own experience with unplanned parenthood galvanized her determination to bring important birth control and reproductive health issues into the light of day.

Marietta's professional success was offset by personal tragedy when Jerry fell victim to a lingering illness. She was at his bedside in April 1950 when he slipped away at age fifty-eight. The depth of her grief was only hinted at in his obituary, which noted that Mrs. Vasconcells was "under a nurse's care and not seeing visitors."

Marietta retreated to a PR job in Phoenix, where she and Jerry had often wintered. Concerned, her dearest friends sent "Sir Galahad" to the rescue. Galahad was a 1937 Packard, a gift to Marietta from Jerry on her thirty-ninth birthday. Her husband had ordered the car in blue to match his two favorite things in the world: his wife's eyes and the Colorado skies. For fifty years, the distinctive motorcar was Marietta's gallant companion.

Back home in Denver, Marietta served as chairwoman of Citizens for Eisenhower during the 1952 election campaign. That same year, she ventured into the fledgling world of television, hosting a popular local interview show on KFEL-TV. Her face and name became familiar to all in the city, not

Marietta and "Sir Galahad." *Rocky Mountain News*, April 3, 1977.

only as a society maven but also as a media maverick who paved the way for subsequent female journalists and broadcasters.

Marietta married a third time in 1954. George Bakewell Jr., a widower himself, was a kind and considerate companion. He wasn't even jealous of Sir Galahad. She had twelve happy years with George before losing him to a long illness.

For twenty more years, Sir Galahad escorted the aging widow on short trips to the grocery store, the beauty salon or the Denver Country Club. She confessed to a newspaper interviewer in 1987 that her vision was failing and that she was painfully resigned to selling her beloved Packard, a last link to her racy past. "When he's washed," she said, "he looks pretty good for an old guy. To get rid of him, it's an awful wrench."

In her later years, Marietta reconnected with her son, Lafe Franklin, his four children and a grandson. She also embraced George's six grandchildren as her own. "They give deeper dimension to my life than I ever thought possible," she said. At the request of a granddaughter, Marietta penned the memoirs of her extraordinary life. Titled "Another Pilgrim's Progress," the manuscript remains in the files of the Brown Palace archives.

EDNA BOETTCHER: LASTING IMPRESSIONS

She was slender and sophisticated. She wore lip rouge and fashionable bobbed hair. She was the most desirable widow in Denver when Claude Boettcher added her to his collection of priceless treasures in 1920. Vestiges of Edna Boettcher's style and influence are evident in the Brown Palace to this day.

Coloradans still associate the Boettcher name with finance and philanthropy. Three generations of Boettchers owned the Brown Palace, but it was Claude Boettcher who masterfully piloted the hotel through the high seas of the Roaring Twenties, the doldrums of the Great Depression, the maelstrom of World War II and into the safe harbor of the 1950s. His marriage to Edna Case McElveen was not his first, nor hers. But it was the beginning of a long and convivial partnership that suited them both. Their impeccable taste, social connections and business savvy combined to reshape the Brown Palace in myriad significant ways.

Edna had been widowed for thirteen years when she wed Claude, known as "C.K.," Boettcher. His first wife, the former DeAllen McMurtrie, had divorced him after a twenty-year union, dismayed by his frequent prolonged absences on business jaunts. DeAllen was well provided for with an out-of-court settlement. Their only son, Charles II, was soon off to Yale.

Claude Boettcher was often characterized as distant, intense and brilliant. Various national magazines listed C.K. among the wealthiest, most powerful

Edna (Mrs. C.K.) Boettcher. *Courtesy Denver Public Library, Western History Collection.*

and best-dressed men in America. A second-generation Colorado capitalist, C.K. Boettcher was born into the fortune built by his father, Charles. As a young German immigrant, the family patriarch made his first million selling hardware supplies to Leadville miners during the 1870s and 1880s silver boom. Charles soon parlayed his profits into securities, livestock, utilities, transportation, cement and the fledgling Colorado sugar beet industry.

By 1920, the gradual estrangement from his wife Fanny became a legal separation, and Charles moved into the businessman-friendly Brown Palace.

Two years later, he bought the place, in partnership with Horace W. Bennett. When Bennett was forced to divest himself of several financial encumbrances in 1927, C.K. persuaded his father that the two of them ought to buy out Bennett's share of the Brown. Charles was not convinced that the hotel was a wise investment. But C.K. never wavered in his conviction that Denver needed a preeminent hostelry and that under his leadership the Brown would succeed beyond all expectations.

C.K. and Edna gloried in a life of carefree affluence in the 1920s, with fast cars, elaborate parties and illicit, Prohibition-defying spirits. The Boettchers traveled the world in search of foreign antiquities and rare *objets d'art* made available by the postwar dismantling of European and Oriental palaces, villas and chateaus. From France, Britain, Venice, Austria and China they selected the finest silver, crystal, cloisonné, marble, jade and lacquered pieces. Furniture, tapestries, vases, chandeliers and gilded mirrors that caught their fancy were promptly shipped to Denver. Such spectacular acquisitions called for equally spectacular showcases.

In 1928, C.K. purchased the twenty-seven-room Cheeseman mansion at Eighth and Sherman Streets. The following year, he presented the deed to the house to his wife as a Valentine's Day gift. In their new home, as in their lives, Edna and C.K. incorporated classical elements with modern style. Edna swept away the Victorian clutter and fussy details and replaced them with the smooth lines and muted colors of the Art Deco style popular at the time. Their European and Oriental antiques and art objects stood out all the more dramatically in the updated setting.

Special lights were installed in the dining room chandelier that could be subtly adjusted in hue and intensity. The settings on any given occasion were calculated to complement Edna's gown and jewels. The standout piece in Mrs. Boettcher's collection of precious gems was the "Maharaja of Singapore." A ring with the emerald-cut diamond, variously reported as twenty or forty carats, was purchased in Paris by C.K. as a special gift.

It was in the octagonal sitting room of her second-floor suite that Mrs. Boettcher once encountered a would-be thief. He had gained access via a ladder left by a careless painter earlier in the day. Startled by her entrance, the home invader drew a gun. Edna kept her cool and thought fast. She lied that there were several guests in the Palm Room directly below who would surely hear any commotion from above. She advised the burglar to leave quickly and quietly, and he wisely complied, departing the way he'd come without a single piece of Boettcher loot.

Broadway and Tremont Street corner of the Ship Tavern.

Edna supported C.K. through one of the most harrowing incidents of his life when Charles Boettcher II was kidnapped in 1933. C.K. was willing and able to pay the $60,000 ransom, but because of inept police handling of the case, the ordeal continued for more than two weeks before the cash was delivered and his only son was released unharmed. Speculation persists to this day that Colorado's "Crime of the Century" was actually engineered by Charles II himself as a way to get money out of his tightfisted father.

On a trip to Cape Cod in the 1930s, C.K. acquired more than a dozen scale-model clipper ships. Based on real ships of the mid-1800s, the replicas were accurate in every detail of sails and outfitting. Most of the models were more than three feet long.

When Claude presented this ship collection as a surprise gift to Edna, she was less than thrilled at the prospect of big toy boats dominating the décor of their mansion. Diplomatically, she suggested that the new tavern C.K. was planning for the Brown Palace, to celebrate the end of Prohibition in 1934, reflect a nautical or maritime theme. He could display the model ships—and get them out of the house. C.K. took her

recommendation and created the Ship Tavern. The oldest of the hotel's restaurants, the Tavern is very little changed from the day it opened, more than seventy-five years ago.

Years later, many of the Boettchers' Napoleonic-era artifacts would decorate the hotel's Palace Arms Restaurant. The private dining room of this elegant high-end venue occupies space that was the original Grand Entrance to the hotel. Centered on the Broadway side of the building, the rooftop cornice and bayed windows from top to bottom gave it a much more impressive appearance than either of the two entrances used today. A bas-relief profile of Henry Brown and a medallion with his initials flank either side of the entrance. At the time the hotel opened, no one could have foreseen that ever-increasing auto traffic on Broadway in the twentieth century would eventually make loading and unloading guests on that side too dangerous. The Grand Entrance, presenting an impressive diagonal view of the atrium lobby, was finally closed, and the Palace Arms opened in its place in 1950.

Helmets, sabers, armor, pistols and other pieces from France and England, circa 1790s–1850s, adorned the fine dining space. Ornate ceiling and side mirrors completed the opulent look of the room, where the award-winning cuisine and wine selections would continue to equal the décor.

Mrs. Boettcher was renowned at home and abroad for her entertaining, in both the Denver mansion and their elegant winter home in Palm Beach, Florida. Guests were charmed by her wit and her flair for memorable party staging. Her annual costume balls were glowingly reviewed in local newspapers the next morning. She counted Wallace Simpson among her friends, long before Edward VIII abdicated the English throne to marry the American divorcée. Subsequently, the Boettchers were the first to entertain the Duke and Dutchess of Windsor when they debuted in American society in 1941. Other prominent guests over the years included Charles Lindbergh, a friend of C.K.'s son, and Dwight and Mamie Eisenhower.

Mrs. Boettcher served for many years on the board of the Boettcher Foundation, established by C.K in 1937. Grants from the foundation supported religious, scientific, cultural and educational organizations and endeavors, with the stipulation that all uses of the funds directly benefit the people of Colorado. It was the Boettchers' way of giving back to the state that had enabled their family to prosper. The foundation continues its philanthropy today and every year awards full-ride scholarships to outstanding college-bound high school graduates.

C.K. preceded his wife in death in 1957. Edna found comfort in the close companionship of her sister, Virginia Case Schaefer, who lived in

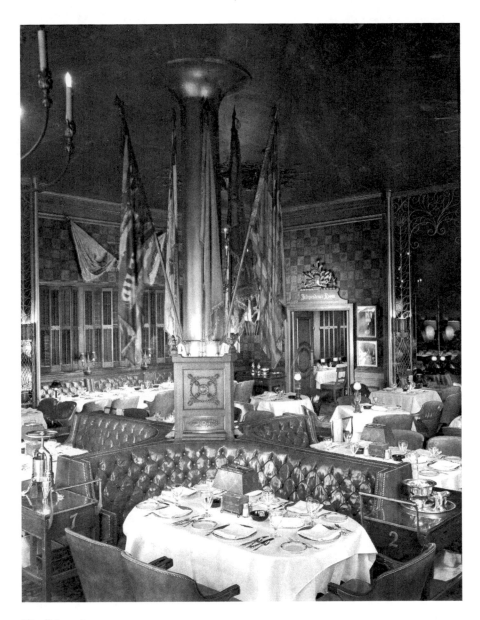

The Palace Arms.

the Pennsylvania Street mansion next door. Gradually, Edna eased her way back into the social scene. In the fall of 1958, while hosting a small dinner party in the mansion's Chinese Room, Mrs. Boettcher was felled by a fatal stroke.

She willed the Denver mansion and all its contents to the Boettcher Foundation, which in turn offered the gift to the State of Colorado for use as the governor's residence. Incredibly, the state initially rejected the generous offer, due to controversy within the legislature and vacillating public opinion. On the eve of 1960, the foundation prepared to raze the building and auction off its contents. In the eleventh hour, Governor Stephen McNichols, who had grown up in the Boettcher mansion neighborhood, managed to negotiate with the foundation and establish an annual maintenance fund of $15,000 to seal the deal.

When Charles Boettcher II presented the Boettcher mansion deed to the State of Colorado in an official ceremony, Edna's last wish became a reality. Her former home not only shelters the state's First Family but also welcomes visitors throughout the year. Edna Boettcher's taste and times are still beautifully reflected within its rooms, as well as in the historic restaurants of the Brown Palace.

Part III

Famous Ladies

SARAH BERNHARDT: DIVINE DIVA

Considered by many the foremost actress of her day, "the Divine Sarah" swept into Denver on two occasions. When the Great San Francisco Earthquake of April 1906 destroyed the theatre in which she was scheduled to perform, Madame Bernhardt accepted the invitation of Mary Elitch Long to appear at her beautiful Theatre in the Gardens.

Mary had opened the former Chilcott Farm as Elitch Gardens with her late husband John in 1890. Lovely pathways meandered through orchards and flower beds, and huge cottonwoods provided shade for picnickers who caught the streetcar from Denver to the Highlands, five miles north of Denver. Elitch's was also the first zoological gardens between the Mississippi and the West Coast. Tenderhearted Mary began her menagerie by adopting animals from the Barnum and Sells-Floto circuses that wintered in Denver. She rescued both those animals too old to perform and unwanted young.

Tragically, soon after the close of Elitch's first successful summer season, John passed away from pneumonia while touring with his vaudeville troupe in California. His devastated thirty-four-year-old widow resolved to keep the Gardens going and growing in John's memory. Even with no business background, Mary oversaw every aspect of the operation, essentially alone. However, after ten years, her trusted manager, Thomas D. Long, became her second husband.

Mary's main addition to Elitch's grounds for its second season was the playhouse of which John had always dreamed. She spent every subsequent

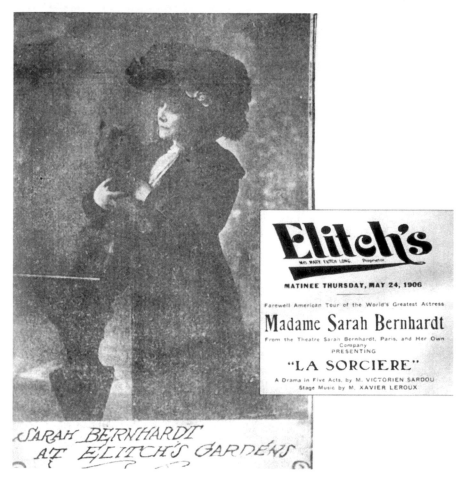

Sarah Bernhardt with Elitch's playbill. *Courtesy the Gurtler family.*

winter in New York City and San Francisco, seeing the newest plays and recruiting top-notch talent for the Theatre in the Gardens. Elitch's eventually became the longest-running summer stock theatre in America, featuring national stars such as Douglas Fairbanks, Tyrone Power and Edward G. Robinson.

Meeting the legendary Sarah Bernhardt was one of the greatest thrills of Mary Elitch Long's life. The internationally famous Bernhardt had been captivating audiences and critics for decades with her golden voice, expressive face and entrancing presence. In 1880, Bernhardt had severed her ties with the Comédie-Français and started her own touring theatre company, the toast of the Continent and the United States. It took nothing

less than an earthquake to bring her troupe to the Colorado capital city, regarded by many at the time as an unsophisticated cow town.

Mary Elitch Long never forgot her first encounter with Madame Bernhardt in the Gardens. The two women formed an immediate unspoken bond as spirits equally passionate about drama and the wonders of nature. They wandered the grounds together, drinking in the beauty of the flowers and the blossoming trees. When they came to the animal cages, Mary witnessed a remarkable incident that she later recounted for her biographer.

Bernhardt, Mary recalled, ranged swiftly past the cages of many beautiful animals, almost as if drawn to the furthermost enclosure, wherein a young female mountain lion paced back and forth, restless and agitated:

As Sarah Bernhardt neared the cage, the uneasy creature stopped and watched, then coming to the bars, pressed as closely as possible to them, staring, seeming not to breathe, completely fascinated. Before I knew what she was doing, the actress pressed against the cage and reached up to fondle the animal's head. Gently she stroked the passive creature, beginning at the very tip of her nose and smoothing back over the velvet ears. While feeling acute terror for her, I, too, was fascinated, for I realized the complete subjection of a beast to the strange power of this marvelous woman. Had I not felt it also in that first moment of our meeting?

When Bernhardt asked the lioness's name, Mary replied that the young cub had not yet been given one. Thereupon the actress grandly christened the animal after herself, and the leonine Sarah Bernhardt remained one of the most popular Elitch's animal attractions for the rest of her days.

Madame Bernhardt generally abhorred doing matinee and evening performances in the same day, with mere hours to collect herself in between. It is a testament to the persuasive powers of Mary Elitch Long that the actress performed twice on May 24, 1906, at the Theatre in the Gardens. The afternoon presentation of *La Sorcière* was matched, and perhaps eclipsed, by that same evening's *Camille*. Afterward, the Divine Sarah added her autograph to the ever-growing collection on the gray door backstage at Elitch's Theatre.

Though her first visit had been billed as the "Farewell American Tour of the World's Greatest Actress," Bernhardt returned to Denver in May 1911. This time, her suite at the Brown Palace overflowed upon her arrival with bouquets and cards from devoted Denver admirers.

Astonishingly, at sixty-seven years old, the thespian extraordinaire convincingly portrayed the imprisoned young son of Napoleon in *L'Aiglon*. Gender-bending was nothing new to the versatile actress; she had just completed a run in the lead role of *Hamlet*, a huge critical and financial success. Denver's theatre reviewers raved about her performance. The writer for the *Daily News*, after making small mention of inevitable signs of age in Bernhardt's famous features, ended her review with an exuberant "Oh Queen, live forever!" Particularly impressed by the skill and persistence demonstrated by the older actress was a would-be local actress with stage aspirations of her own—*Titanic* heroine Margaret "Molly" Brown.

Bernhardt's signature in the Brown Palace guest register, May 14, 1911 (fifth line from the bottom).

Years later, Margaret studied and performed Bernhardt's roles under her former instructor in Paris. She was awarded the Palm of the Academy of France in 1929 for her interpretations of the famous actress's work. Consummate fan and mimic Margaret paid regular homage at the Divine Sarah's tomb and acquired several of Bernhardt's famous gowns.

Sarah Bernhardt was among the first actresses to successfully transition from the stage to the screen. In 1912, she became a motion picture star with *Camille*. Though she never returned to Denver, the film was embraced by her local admirers, many of whom had seen her perform in the same role at the Theatre in the Gardens half a dozen years earlier.

HELEN KELLER: SHINING THROUGH

The acquisition of language through finger spelling at the age of ten was only the beginning for Helen Keller, deaf, mute and blind since infancy. Incredibly, she went on to graduate *cum laude* from Radcliffe and to become

Sunshine through the atrium stained-glass skylight. *Courtesy James Faulkner.*

a world-renowned writer and speaker. On three different occasions, when she made appearances in Denver, Miss Keller stayed at the Brown. Despite her sensory impairments, Colorado's beauty and the hotel's splendor were not lost on her.

On February 22, 1914, Helen Keller's famous teacher, Annie Sullivan (Mrs. J.A. Macy), registered in Brown Palace room 500. Helen and her mother, Mrs. K.A. Keller, occupied adjoining rooms 502 and 504. Every guest chamber in the triangular Brown was an exterior room. Before the hotel was surrounded by skyscrapers, guests were customarily asked when signing in if they preferred morning sun in their rooms or afternoon sun. Apparently Keller's party opted for the morning rays. A *Denver Post* reporter visiting Helen at the Brown wrote, "Miss Keller stood in her room this morning, her sightless eyes turned to an open window. As a sunbeam fell across her face, she said, 'How good it is to be in this state. The sun is perfect here.'"

Denver's Orpheum Theatre, where she was appearing, billed her as the "Most Talked of Woman in the World." She would be followed at the Orpheum the next week by "Sawing a Woman in Half—A Beautiful Girl Severed in Twain." Though Helen was respected for her amazing accomplishments, she was nevertheless considered something of a curiosity.

Her speech, described as "pathetic" by one reviewer, could be very difficult for audiences to understand. A *Denver Post* reporter wrote that "it touched the hearts of the audience and also made them wince."

Miss Keller's carefully chosen words repaid the effort of listening. She used her fame to crusade for financial assistance that would enable other handicapped children and adults to lead full and productive lives. At a "subscription luncheon" at the Brown, Helen spoke slowly in a voice she herself would never hear.

"I was alone," she said, "imprisoned, with no language but a cry. Then the miracle—my teacher came and made my life bright with friendship, knowledge and accomplishment. It is because she cared about me and helped me to overcome my limitations that I am able to work for myself and others." While in Denver on that first visit, she also spoke before the state assembly in support of pending legislation to assist the blind of Colorado.

As a public figure, Helen was asked her opinion on every topic of the day. At a 1914 press conference in the Brown, she declared her support for socialism, women's suffrage, violence by labor unions "when justified" and the enforcement of eugenics. In another interview in the mid-1920s, Keller defended the scandalous young women known as "flappers," contending that once given useful employment, they would do themselves proud.

Keller's 1921 visit to Denver coincided with an appearance by internationally acclaimed violinist Jascha Heifetz. Heifetz played a private concert for Helen at his suite at the Brown. Though she could not, of course, hear the music or see his performance, the virtuoso allowed Helen to lightly touch the instrument to feel the vibrations as he played. A *Denver Post* reporter present at the remarkable event wrote, "All eyes were on the blind woman as she placed the tips of her wondrously sensitized fingers under the belly

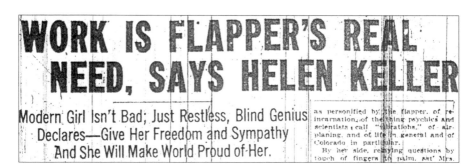

Keller headline from the *Denver Post*, February 18, 1925.

of Heifetz's Stradivarius. The melody swept through her being. Her body responded to every note."

Miss Keller "saw" with her heart and her soul. On an excursion west of Denver, she could sense the majesty of the mountains around her. She described their aura as "a great, beautiful bigness, with the sun shining down on them. Bright, bright!"

Her message to audiences was always positive and optimistic. "I want to tell you, that though I stand here deaf and blind, I find joy and beauty in life," she often said. She spoke at the state capitol, the University of Colorado, Central Presbyterian Church, City Auditorium and other downtown hotels, always on behalf of the American Foundation for the Blind. Keller urged her audiences to be generous in filling out their pledge cards, saying, "There is no surer way to keep the fire of happiness burning in our own hearts than by sharing its brightness with others." Her 1925 three-page speech, typed on Brown Palace stationery by an assistant, concluded: "Together we shall hasten the day when there will be no blind child untaught, no blind man or woman unaided in this great land. Then indeed will God's face shine upon us."

MILDRED "BABE" DIDRIKSEN ZAHARIAS: ALL-AROUND ATHLETE

On July 4, 1947, the mayor of Denver proudly handed an oversized key to the city to "hometown girl" Mildred Didriksen Zaharias. The thirty-three-year-old athlete had just returned from winning the British Women's Amateur golf tournament, the first American ever to do so. By that time, she had been a Denver darling since 1932, when she dashed through town, along with the rest of the women's track and field team, en route to the Summer Olympics in Los Angeles, California. "Babe" and her teammates had enjoyed a banquet and complimentary stay at the Brown on that first visit. Fifteen years later, she had no need of a hotel room, as she had made her home in the Mile High City since marrying professional wrestler George Zaharias, a Colorado native.

Mildred earned her nickname early, when her stellar baseball skills reminded many of famous slugger Babe Ruth. But baseball wasn't the only sport in which Didriksen excelled. At high school in Beaumont, Texas, she simultaneously aced volleyball, basketball, swimming and tennis. Recruited upon graduation to play for the Golden Cyclones, a women's Amateur

Athletic Union (AAU) basketball team, she was a three-time all-American in the sport. Never one to rest on her laurels, Babe moved on to conquer softball and track and field.

At the AAU Championship in 1932, Babe became a newsreel sensation by competing as a one-woman team in all nine track and field events and winning the meet all by herself! In the high jump, javelin throw, baseball throw and eighty-meter hurdles, she set world records. Who better to represent her country in that year's Olympics?

Always on the lookout for publicity angles, the *Denver Post* fêted and featured the young women of the U.S. track and field team when they stopped in town on July 19, 1932, for two days on their way to the Los Angeles summer games. The Brown Palace put them up for free and provided breakfast. The female athletes worked out at University of Denver and put on a few exhibition events in Merchants Park, where Babe and others noticed the effects of the altitude on their athletic performance. The next day, the sixteen-member squad was chauffeured around the Denver Mountain Parks in brand-new Hudson-Essex Pacemakers before a luncheon in their honor at the Denver Athletic Club.

Every local news story about the team called them "girls." One *Denver Post* article listed the athletes under their events and included brief characterizations of each—college and high school students, two teachers, two stenographers, a bookkeeper, a housewife and a "home girl." Babe was simply "Ace of the Squad."

At the Olympics, Babe captured two gold medals and a silver—in hurdles, javelin and high jump, respectively. The second-place finish surely stuck in her craw. She lost points for her unorthodox headfirst style, which later became standard high jump technique.

Soon a press and public favorite, Babe took her show on the road after the Olympics. She barnstormed around the country, showcasing her versatile athletic skills in various crowd-pleasing stunts. She stepped up to the plate on an otherwise all-male baseball team and once even challenged the Kentucky Derby winner to a one-on-one dash.

Babe next set her sights on golf. Few women played the game seriously at the time, but few women had the drive and athleticism of Didriksen. She defied the gender barrier by qualifying for the PGA's Los Angeles Open. Her golf partner in that tournament soon became her life partner and manager, George Zaharias. Before turning professional in 1947, Babe won seventeen consecutive amateur golf tournaments in one season, playing for Denver's Park Hill Country Club. She was soon acknowledged to be the top female

golfer in the PGA and helped to establish the Ladies' Professional Golf Association (LPGA) in 1950.

Babe broke records and shattered stereotypes. She defined the twentieth-century female athlete. The long, tall Texan was strong and wiry. With cropped hair and an athletic wardrobe, there was no feminine fussiness about her. She worked all her life to be the best and wasted no breath on false modesty. Babe could talk smack as well as any swaggering male athlete. And she had the talent to back up her braggadocio. When asked once by a reporter if there was anything she didn't play, Babe answered, "Yeah, dolls."

When the Zahariases moved to Denver in 1943, Babe undertook a new kind of challenge. She became special consultant to the Denver Juvenile Court, helping young women who strayed into trouble find new direction and self-esteem through sports.

The "Wonder Girl" finally met her match in colon cancer. She died in 1956. Inducted posthumously into the Colorado Sports Hall of Fame, the National Women's Hall of Fame and the Colorado Women's Hall of Fame, Babe was also honored as "Woman Athlete of the 20th Century" by the Associated Press as the new millennium dawned.

Visitors to the Brown Palace who speculate on the possible identity of figures portrayed in the murals above and opposite the hotel's elevators

Allen Tupper True's 1937 mural in Tremont lobby.

often suspect that Babe Didriksen Zaharias lives on in the artwork. The two scenes were created for the Brown in 1937 by Allen Tupper True, a public muralist with the WPA during the Great Depression whose work also appears in the rotunda of the Colorado State Capitol. Commissioned by hotel owner C.K. Boettcher, the complementary scenes depict changes in travel and transportation over the decades. Visitors arriving in Denver in the early days of stagecoach lines are contrasted with "modern" tourists on a DC-3 airliner. Pointing out the golf bag being unloaded from the luggage hold, many deduce that the woman emerging from the plane was modeled on Babe herself.

True's granddaughter and biographer, Victoria Tupper Kirby, thinks that an intentional portrayal is highly unlikely. According to Kirby, True never depicted actual individuals in his murals. Nevertheless, the woman stepping off the plane does bear a striking resemblance to Babe, a media superstar at the time the painting was done. And what about the man in the tan trench coat to the far right in the same picture? Standing apart from the others and checking out the aircraft with special interest, he looks an awful lot like another celebrity of the era, millionaire Howard Hughes.

Debbie Reynolds: Spunky Songstress

Denver police estimated the crowd waiting outside the Brown Palace at 1,000. Debbie Reynolds at last emerged from a champagne dinner and climbed into an antique auto, guided by the Gold Sash Marching Band to the world premiere of the June 1964 movie musical *The Unsinkable Molly Brown*. Another 2,500 jammed the street outside the Denham Theatre to cheer the star, wearing a gorgeous red dress from a party scene in the film, as she was escorted inside by handsome Colorado governor John Love. Her costar, Harve Presnell, had the honor of squiring Mrs. Ann Love to the event. Inside, popular local radio and TV personality Pete Smythe introduced the guests of honor, including the MGM studio exec and the film's producer. It may have been the biggest thing to happen to Denver since…well…Mrs. J.J. Brown herself.

Never mind that the movie Molly was a far cry from the real Margaret Brown, on whose true story Meredith Wilson's spritely musical was loosely based. Triple-threat Hollywood actress Debbie Reynolds sang and danced

Movie poster for *The Unsinkable Molly Brown* starring Debbie Reynolds.

the heck out of the character, to the delight of moviegoers everywhere. Her performance made *Unsinkable* the third-largest grossing film of 1964 and earned Debbie a Best Actress Oscar nomination.

Debbie, whose given name was Mary Frances Reynolds, racked up a series of movie musicals and hit records, beginning with 1952's *Singin' in the Rain*. Though only a nineteen-year-old newcomer when she played Kathy Selden in that classic film, Debbie held her own on the screen with veterans Gene Kelly and Donald O'Connor. At about the same time, she shot up the Hit Parade with songs like "Aba Dabba Honeymoon," "Tammy" and "A Very Special Love."

Hearts went out to the seemingly sweet and wholesome star in 1959 when her husband, Eddie Fisher, dumped her for seductive film temptress Elizabeth Taylor. That same year, Reynolds released her first album on Dot Records. Titled simply *Debbie*, it showcased her versatile voice and interpretive talent. Ms. Reynolds was only one in a long line of beautiful songstresses who graced the Brown from the 1940s through the 1960s.

Other female recording artists with a knack for song styling performed at the Brown over the years. They lent their lovely voices to the orchestras of Jules Duke and Lou Morgan for dining and dancing. The hotel's popular Emerald Room opened on Thanksgiving Eve 1941, in the midst of the big band era. Located in the space now occupied by Ellyngton's, the Emerald featured two shows nightly, at 9:30 p.m. and 11:30 p.m.

Dancers in the Emerald Room, 1956.

The modern baroque bandstand was biscuit tufted in "flirt pink" satin and flanked by huge metal plumes. White music stands featured green lyre motifs. The entire stand was on castors so that it could be moved to accommodate dancers. The adjacent Alibi Bar was decorated with emerald green mirrors and blond furniture upholstered in flirt pink plaid.

Dinner prices started at $1.50 weeknights and at $2.00 Saturdays. Dinner guests paid no cover charge, but those who came for dancing only paid $0.75 on Thursday, Friday and Sunday or $1.00 on Saturday. As a service to those for whom the prices were out of reach, Denver's KOA radio often broadcast the music live to envious listeners at home.

Among the pretty songbirds to warble at the Brown were Connie Towers, "Loveliest of the Singing Stars"; Denise Darcel, "France's Curvaceous Gift to Hollywood"; Dorothy Shay, "The Park Avenue Hillbillie"; Evelyn Knight, "Denver's All-Time Favorite"; and Mindy Carson, "Blue-Eyed Cinderella Girl." (While appearing at the Brown in 1956, Miss Carson confidently predicted in an interview that the rock 'n' roll craze would soon die out.) Joanne Wheatley was billed as a "Dynamic Blend of Sight and Sound." And Anna Maria Alberghetti was said to possess "a voice that can teach the angels. Stardust—and plenty of it!"

EMERALD ROOM
October 3 through 11

MINDY CARSON

Blue Eyed Cinderella Girl
Lovely stylist of radio, stage, screen and television.
Featured singer on NBC.

with

Lou Morgan

and his orchestra

Two shows nightly Phone TAbor 3111
9:30 and 11:30 for reservations

★ ★ **BROWN PALACE HOTEL** ★ ★
HARRY M. ANHOLT, MANAGER

Return Engagement

Lovely

EVELYN KNIGHT

"Denver's All-Time Favorite"

April 9 thru April 18
EMERALD ROOM

Dinner Dancing with **Lou Morgan** & Orch.

Two shows nightly Phone TAbor 3111
9:30 and 11:30 for reservations

★ ★ **BROWN PALACE HOTEL** ★ ★

Female song stylists performing in the Emerald Room.

Though the swing sound failed to grab the "peace and love" generation in the 1960s, the Brown's older patrons appreciated a place where they could still enjoy the easy listening sounds of decades past. When the Emerald Room was transformed into the San Marco Room in 1959, Art Gow and his orchestra continued to play the big band standards. Fronted by singer Betty Perry, Gow's orchestra recorded two long-playing albums for their many Brown Palace fans.

The San Marco Strings were strolling musicians who drifted from table to table to serenade romantic diners. Their Liberace jackets were

substantially louder than their music. But what some considered "pop classics," others called "schmaltz." Victims of inevitably changing tastes, the San Marco musicians were abruptly dismissed without warning, just before Christmas in 1986.

Musical styles may come and go, but genuine talent endures. In the liner notes for Debbie Reynolds's first album, iconic crooner Bing Crosby wrote: "She's made [these songs] her own and invested them with a sincerity that's inescapable—of contrasting moods, to be sure, but mighty effective. And that, *mes ami*, is artistry."

The long thread of live music tradition at the Brown still runs through Ellyngton's restaurant. Though the space is now primarily a breakfast and lunch venue, a three-piece combo jazzes up every Sunday Champagne Brunch, as well as special Christmas breakfasts with Santa and Mrs. Claus. Some of the sugar-infused little dancers who kick up their heels at those events could teach the irrepressible Ms. Reynolds a move or two.

ZSA ZSA GABOR: ANIMAL MAGNETISM

Reigning cats and dogs didn't always receive a royal welcome at the Brown Palace. When the spoiled actress Anna Held tried to room with her miniature French poodle Blackie in 1911, the hotel refused to accommodate her pet. Despite the best bribery efforts of Anna's husband, famed Follies producer Flo Ziegfeld, the desk clerk declined to look the other way and allow the dog in their suite. Over the years, the Brown's policy toward animal companions has softened substantially. Few nonhuman guests have caused problems, but there are, of course, historical exceptions. One of the most exasperating episodes for the Brown staff involved a kitten belonging to the glamorous Hollywood star Zsa Zsa Gabor.

The Hungarian Gabor sisters turned Hollywood on its ear when they arrived on the scene in the early 1950s. Middle sister Zsa Zsa made her film debut in 1952's *Lovely to Look At* and was soon given starring roles in *Moulin Rouge* and *Lili*. She was a working actress, not above appearing in cult films like 1958's *Queen of Outer Space*. But her real celebrity came from her flamboyant and witty persona. Zsa Zsa was known for her multiple marriages (nine total), as well as for her clever observations on the subjects of love and matrimony, including "A man in love is incomplete until he marries. Then he's finished," and "Husbands are like fires. They go out when unattended."

She once claimed that she was a good housekeeper, because every time she got divorced, she kept the house.

Zsa Zsa was between husbands number five and six when she checked into the Brown in 1970 with Miss Pussycat, her white Persian. Though the official reason for her visit was to promote her own cosmetics company, Zsa Zsa Ltd., she always visited the Denver Dumb Friends League animal shelter with her friend, Sheila Marlowe, a member of the DDFL Board of Directors, whenever she came to town. As usual, Ms. Gabor wanted to take all of the cats and dogs home with her. The actress persuaded two other visitors at the shelter that day to adopt a poodle puppy, telling them, "Animals make the best friends in the world. You'll never regret it. They will give you so much love."

The DDFL gifted Zsa Zsa with two kittens that had stolen her heart. When it came time for Ms. Gabor to sweep on to her next engagement, one of the kittens could not be located. From the sound of its mewing, it seemed to have crawled under the radiator in her room and gotten lost in the hollow terra-cotta blocks between floors. With no time to retrieve the missing animal, the impetuous actress instructed hotel staff to "Ship it to me, Dahling!" as she waved goodbye.

When repeated attempts to reach the kitten failed, someone suggested setting out a plate of sardines from the hotel kitchen. The aromatic lure proved just the motivation the cat needed to find its way out of the maze on its own. A relieved assistant manager gathered it up and packed it off to Ms. Gabor's Beverly Hills mansion.

Zsa Zsa's kitten was not the first feline to ruffle fur at the Brown. In 1909, Lizzie, the unofficial hotel cat, was prowling around the open atrium on a balcony railing when she lost her balance and fell seven stories to the lobby floor, startling guests assembled there. Knocked out cold for several hours, Lizzie astonished everyone by reviving and walking away to stalk mice another day. Surely several of her nine lives were used up in the effort.

It is unclear whether Lizzie or another cat left its mark in a patch of wet concrete in one of the Brown's basement storage rooms, but the paw prints remain. When Morris the Cat, discriminating gourmet star of TV cat food commercials, visited the hotel in October 1973, the Brown used those prints to create special stationery for him.

Dogs, too, have quite a history at the Brown. In 1896, the hotel welcomed a dog with money of his own. An ailing fox terrier, legal heir to the fortune of a Philadelphia millionaire, traveled to Denver on the advice of his veterinarian, who believed that the mile-high climate would be as beneficial

for canine tuberculosis as it was for desperate human consumptives in the late 1800s. This pitiful pooch arrived with his own entourage and scaled-down furniture—not to mention a $50,000 inheritance—and booked a seven-room suite on the second floor.

In 1976, the Brown welcomed Augustus von Schumacher, canine star of *Won Ton Ton, the Dog Who Saved Hollywood,* a spoof based on the movie and TV adventures of Rin Tin Tin. "Gus" wore a dog collar necklace created by none other than Zsa Zsa's mother, Joile Gabor. The handsome German Shepherd counted among his acting colleagues such names as Madeline Kahn, Art Carney, Phil Silvers and Bruce Dern. Gus made

Paw print stationery designed by the Brown for Morris the Cat.

himself at home in an upper-floor suite and was chauffeured to lunch at a local fine restaurant.

Marathon Hound sprinted through town in 1985 and paused to relax in room 910 at the Brown. Following a three-year career as the top money earner in the history of greyhound racing, the retired Marathon was said to be the most valuable dog in the world. He graciously granted interviews and posed for photo ops in his hotel suite.

The top dog treatment given Marathon Hound set the standard for all animal guests of the pet-friendly hotel. Dogs and cats alike are now pampered with superlative creature comforts. Luxurious beds, silver bowls and special treats created by the Brown's renowned pastry chefs make every pet feel like the "Best in Show."

JOAN BAEZ: MEMORABLE TIMING

Along with fledgling rock 'n' roll, folk music composed the soundtrack of the late 1950s. Groups like the Kingston Trio and Peter, Paul and Mary mined various traditions for songs that resonated with people longing to reconnect to a simpler, down-to-earth vibe that defined the American character for many.

Original songs of social commentary and protest, too, were given voice by artists like Pete Seeger and Bob Dylan. With the purchase of her first acoustic guitar, talented young Joan Baez was not only drawn into this scene but was also soon instrumental in shaping a new and affecting synthesis of the traditional and the political. From the release of her first self-titled album in 1960, Joan soon became an established "folkie," as well as an artistic advocate of social conscience and change.

By 1964, Joan Baez was the acknowledged queen of folk music. But she was taken aback by the thousands of frenzied fans encircling the Brown Palace when she arrived on August 26. As her driver drew near enough to read the crowd's hand-lettered signs, the situation was

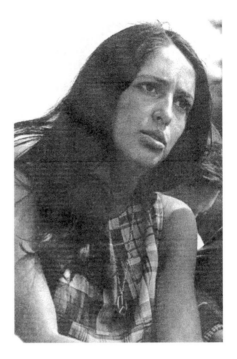

Joan Baez in 1963. *Wikimedia Commons.*

quickly clarified. The teenage throngs had not gathered to greet Baez. They were breathlessly awaiting the Beatles.

An admirer of the "Fab Four" herself, Baez was excited to learn that their stays at the Brown coincided. She struggled through the crowd into the hotel virtually unnoticed. The atrium lobby had been converted into a first-aid station to handle the overwrought and hysterical. Four girls recognized the famous folk singer and begged her to take a note from them to the Beatles' hotel suite. Joan promised to try. Acting on that promise led to the fulfillment of her own wish to meet the famous foursome in person.

The Brown Palace had resisted hosting John, Paul, George and Ringo. The mop-topped pop sensations were a far cry from the Brown's traditionally conservative, straight-laced clientele. But the Beatles' manager had heard that the iconic hotel was the best in Denver, and he insisted on their accommodation. As soon as word leaked out that the Beatles would be staying at the Brown, the hotel's employment office was inundated with applications for housekeeping positions from young girls who wanted nothing more than to touch their idols' dirty sheets or towels.

Top: Ringo exits limo to enter the Brown Palace, August 1964.

Bottom: Red Rocks Beatles ticket.

Brown Palace personnel and the Denver police benefited from lessons learned by other hotels hosting the group earlier on their U.S. tour. Twenty-seven young police rookies got a baptism of fire manning crowd control posts around the Brown from 9:00 a.m. to 3:00 p.m. Security was tight, and timing was crucial in misdirecting the adoring fans' attention with a decoy

limousine as the Beatles were hustled inside via the employee entrance and loaded into a service elevator. Casualties of their arrival included seven girls, briefly hospitalized with bumps and bruises from falling and being trampled, and three policemen, who were bitten, kicked and elbowed in the chaos. One officer had a false tooth knocked out, and another got his nightstick stolen.

An iron-barred gate barricaded the Beatles' eighth-floor suite in the Broadway and Tremont corner of the building. Police flanked the entryway 24/7 to repulse any unauthorized personnel who might miraculously sidestep sentries guarding the hotel entrances and elevators. Other hotel guests, including Joan, though somewhat inconvenienced by the extraordinary circumstances, clearly understood the necessity for such defensive measures by the besieged Palace.

The Beatles played that evening at Red Rocks Amphitheater, an incomparable open-air foothills venue overlooking the lights of Denver. With tickets priced at a then exorbitant $6.60, their concert did not sell out. Just two nights later, Joan performed on the same stage.

Neither Joan Baez nor the Brown would ever forget the episode. Forty years later, she was back at the hotel, in town to perform with the Denver Botanic Gardens Summer Concert Series. Colorado helped her decompress from a recent European tour. She hiked in the mountains, waded in sparkling streams and drank in the incomparable fresh air and scenery, refreshing body and spirit alike.

When she rejoined her tour staff, band and crew at the Brown, Baez was once again surprised by what greeted her. A specially created chocolate record and a beautiful bouquet were accompanied by a note announcing that it was forty years earlier that she had stayed at the hotel with the Beatles.

The Brown commemorates the Beatles' one-night visit with a suite named in their honor. Room 840 is about half the size it was when the British musicians snoozed therein, and its décor bears no resemblance to the 1960s interior decoration. But on one wall is framed an old Beatles 45rpm record, along with a Red Rocks ticket from their appearance and a photo snapped of Ringo exiting his limo to enter the hotel. He and Paul McCartney are the only members of the group to make return visits to the Brown. The legendary drummer checked in while touring with his own band in June 2000 and stayed, of course, in room 840.

Baez's fans are still legion, and her music and message are as relevant as ever. She spoke to the 2004 Botanic Gardens concert crowd about the need to reclaim many jeopardized values that have defined and elevated our

country—compassion, empathy, common sense and "the ability to think…
and to speak the truth." She was joined by 2,200 assenting voices in "America
the Beautiful," its inspiring lyrics penned by another great American poet,
Katherine Lee Bates, as she admired the view from atop Pikes Peak more
than a century earlier.

Part IV

Working Ladies

Edna Stewart: Take a Letter

Always a top-drawer businessman's hotel, the Brown Palace offered a public stenographer as a guest service in the early 1900s. Edna Stewart, a graduate of Denver's Central Business School, filled that role from 1929 to 1936. Women were entering the office workplace for the first time in the 1920s, and speed stenographers were in great demand. Competent, ambitious young ladies could earn a good living taking dictation. Before joining the Brown Palace staff, Edna had sharpened her pencils and clerical skills as secretary to the rector of Denver's Immaculate Conception Cathedral. She subsequently scribed for the owner of Rocky Mountain Fuel Company, Josephine Roche—the same Josephine Roche who years earlier had served as Denver's first female police officer and "Inspector of Amusements."

The capable Miss Stewart sat at a desk behind a two-foot-high mahogany barrier in the Brown Palace lobby, "Where the World Registers," taking dictation from both the obscure and the famous. Presidents and cattle barons, diplomats and underworld figures all availed themselves of her services at one time or another. Discreet throughout her tenure at the Brown, Edna had plenty to spill in the memoirs she penned after retirement in California. She was not shy about dropping names in her never-published book. Excerpts from the manuscript were published in the *Denver Post*'s Sunday magazine *Contemporary* in 1967.

Eleanor Roosevelt dictated several letters to Miss Stewart while staying at the Brown in 1936. The stenographer remembered the First Lady as very

Moral Dangers for Working Girls

U. S. Government Investigators Find the Most Hazardous Occupations Are

1--Domestic Service

2--Hotel Waitresses

3--Factory Girls

4--Trained Nurses

5--Stenographers

WHY do girls go wrong and to what extent do occupation and low wages affect the change? There are to-day about 8,500,000 women workers in the United States.

The United States Government has just made an exhaustive inquiry to learn if the trend of modern industry is hurtful to women, and if their moral qualities are affected by her occupation. Some striking facts have become apparent out of the countless statistics that were officially collected. Of nearly a thousand women made the subject

Inquiry Has Classed Stenography Among the Occupations Surrounded by Dangers.

Article warning young women of workplace dangers. Fortunately, Edna Stewart had only good experiences as a Brown Palace stenographer.

gracious and declared that Mrs. Roosevelt "seemed as young as tomorrow. But what impressed me most," Edna wrote, "was the way she had of making you feel you were the only person in the world."

Miss Stewart recalled Mrs. Roosevelt chatting in the lobby with opera contralto Marian Anderson, a three-time guest of the Brown. A few years later, Mrs. Roosevelt would renounce her membership in the Daughters of the American Revolution when the DAR refused to allow a "colored" woman, Mrs. Anderson, to perform in Washington, D.C.'s Constitution Hall. Eleanor proceeded to arrange for Marian to sing at the Lincoln Memorial in a symbolic moment for the fledgling black civil rights movement.

Working Ladies

Actor John Barrymore once declared to Edna that Denver had more sunshine and sons-of-bitches than any other city he knew. Edna could vouch for the sunshine but had little personal experience with the SOBs. VIPs, on the other hand, were her daily clients. She took dictation from Douglas Fairbanks Sr., actor and Denver native. Madame Ernestine Schumann-Heink, world-famous contralto, once paused in mid-dictation to give a little girl an autograph. Noted actress Trixie Friganza caught Edna quite off-guard one cold winter's evening by flashing the red-flannel "longies" she'd donned beneath her elegant gown.

Some men thought that for $3.50 an hour they could monopolize Edna. Successful theatrical impresario B.F. Keith spent several hours each day during his annual visits dictating letters to Edna. He appreciated her company, as well as her clerical skill, and bent her ear with personal reminiscences long after completing his business.

On one occasion, the Brown actually lent out its stenographer to a frequent VIP guest. St. Louis millionaire Harry French Knight arranged with management for Miss Stewart to accompany him to his ranch to fill in for his ill secretary. It was a week she would never forget. On Knight's huge spread near Granby, Colorado, the rustic-looking log ranch house employed a former Waldorf Astoria chef and twenty servants. The stable was filled with thoroughbreds, and the stream was stocked with trout. Cowboys tended to the actual work of the ranch, which Edna was told cost $10,000 a month to run in the 1930s.

Edna handled correspondence not only for Mr. Knight but also for his eight houseguests, fellow millionaires all. She was called on frequently to join in their games of "Button, Button, Who's Got the Button?" and "Hide the Thimble." Craving more exciting diversion, the distinguished gentlemen decided one day during Miss Stewart's visit to produce their own western movie. "The cowboys were called in to play cowboys, and the cameras rolled," she reported. "It didn't seem to bother the guests a bit that the ranch chores were being neglected while they had their fun."

Edna took her responsibilities as public stenographer very seriously and confessed to sometimes worrying needlessly about issues that were not really her concern. Noticing her anxiety one day as he passed her desk, syndicated newspaperman Gene Fowler asked the public stenographer, "Why don't you let the day's business go through your fingers instead of your brain?"

Directly or indirectly, Fowler's thought-provoking question may have partially motivated Edna's move to California in 1936. She settled into a more low-profile job as manager of the new accounts department for

Western Federal Savings in Los Angeles until retirement. But for the rest of her life, her thoughts drifted back to that desk in the Brown's soaring atrium, where she never knew what sort of people or business might come her way.

ROSALIE SOPER: ON TOP OF THINGS

Once upon a time, on the tenth floor of a nine-story Palace, there perched a tiny penthouse apartment. With one main room, a small bathroom and a dressing room, it was furnished in a mixture of antique treasures and thrift store finds. For the gracious lady who lived inside, it was just right.

When Brown Palace executive housekeeper Rosalie Soper finished up each day, she left her work not so much behind as below. Her rooftop apartment at the hotel was a welcome private sanctuary—except when the phone rang with emergency situations that required her immediate attention.

Her favorite part of the elevated Elysium was an outdoor patio, made gardenlike with evergreen trees in pots, bright flowers in planters and red-and white-striped lawn furniture. Rosalie had been working at the Brown for seventeen years when she confided to a *Denver Post* reporter: "I think it's the only thing that keeps me here when things really get hectic."

Things could indeed get hectic for the woman in charge of keeping house for hundreds of guests every night. Mrs. Soper oversaw a crew of about 140 housekeepers (never called "maids" at the Brown), housemen, laundry and linen room staff, hat check girls, elevator operators and other employees. On top of that, she handled all purchasing of supplies and uniforms.

Having assumed her duties during World War II, when homefront personnel were in short supply, Rosalie inherited the responsibility for departments not typically under the auspices of an executive housekeeper. She supervised general maintenance and carpentry, duties usually delegated to a hotel chief engineer. Furniture repairers and upholsterers, drapery and bedspread seamstresses, decorators and even locksmiths reported to her. She was one of those women who found it hard to say "no" to any assignment entrusted to her.

Rosalie fell into the housekeeping business quite unintentionally while working in the managing director's office at Denver's Park Lane Hotel in 1938. Impressed by her organizational skills, the manager decided to put her in charge of the housekeeping department. Rosalie knew nothing about professional housekeeping at the time, but she soon learned.

Left: Rosalie Soper, 1943.

Below: Soper's rooftop apartment. *Denver Post*, July 25, 1960.

Mrs. Soper came to the Brown Palace five years later. Planning and management skills were key to her success as executive housekeeper. Her staff were motivated by excellent employee benefits, recognition of their hard work and the status of working in one of the West's most prestigious hotels. The extremely low turnover rate among Rosalie's employees was unusual in the hospitality industry.

"We still have aggravating problems with younger employees in the teenage and early twenties," she admitted in the early 1960s, "which is a matter of attitude common to these ages." Mrs. Soper focused primarily on middle-aged employees who responded well to respectful treatment and employment perks. Workload distribution that required persistent industry counteracted the fatigue and disgruntlement common in housekeeping workers.

Mrs. Soper tolerated no idleness. That was understood. Former employee Marge Harmon remembered, "Sometimes when things were slow, we'd read paperbacks. But if Mrs. Soper caught you, that was it." The executive housekeeper could seem stern and unfriendly. She didn't believe that an effective manager should get too chummy with her staff, yet she had a caring heart and a smile that could sell toothpaste. Marge remembered her supervisor's surprising reaction to the announcement that Marge was quitting because she was pregnant. "Mrs. Soper was like my mother," she marveled. "She was so proud and excited for me!"

Rosalie was one of the first Denver business executives to recognize the workforce potential of the city's large Spanish-American population. The many Hispanics she recruited for the Brown were among the hotel's most loyal and conscientious employees. Staff turnover was a chronic problem in the housekeeping field. However, for years Rosalie had no need for classified ads or employment agencies when she sought trustworthy and reliable new staff. She depended instead on her current employees to recommend new candidates of their personal acquaintance, and she was rarely disappointed by those referred to her.

An update on the housekeeping department in the April 1956 edition of the Brown's *World Register* employee newsletter reported: "And, of course, our Rosalie V. Soper is always in the news. None of us really understand how she gets so much done with her many responsibilities." At the time, she was serving as president of the National Executive Housekeepers Association, a position she held for four years—and a full-time job in itself. The NEHA was founded in 1931 as a forum for housekeeping executives in charge of diverse large facilities—hotels, hospitals, universities, military institutions and even

steamships—to share ideas and best practices. Rosalie was the first editor of the *NEHA News*, a publication that evolved into the organization's magazine.

When Colorado's postwar tourism boom created a need for more hotel accommodations, the Brown Palace decided to build an addition. An earlier plan to close off the atrium lobby at the third floor and erect a nineteen-story tower in the center of the original building was wisely scrapped. Instead, a new, complementary structure arose across Tremont Street, connected to the old building by a sky bridge at the second-floor level.

With the construction of the Brown Palace Tower annex in 1959, the hotel added 288 guest rooms. Its opening required Mrs. Soper to undertake a wide range of supervisory responsibilities at two completely different types of facilities—one historical, one modern—with a total of more than 600 rooms. In the process, she pioneered several systems that became standard in hotels throughout the West.

Mrs. Soper worked hard to prepare the next generation of housekeeping professionals. She was instrumental in developing degree courses in executive housekeeping at four college campuses in the late 1950s and early 1960s. Locally, she instigated and taught professional housekeeping and interior design classes at the Emily Griffith Opportunity School. She also instructed a course in housekeeping administration at the University of Denver as part of DU's hotel management program.

"Now that the work requires a college degree," she told a *Rocky Mountain News* reporter in 1964, "there are more and more young women in the field. The salary is so good that men are coming into the field, usually as hospital or military base housekeepers."

By the time Denver and the Brown hosted the nineteenth biennial NEHA Congress in June 1964, the organization had swelled. "With three hundred housekeepers looking for a speck of dust, we'll really have to be on our toes!" Mrs. Soper noted in an interview. The hotel sparkled as it always did. Hostess Soper greeted her peers in a chic suit made from the same material she chose for the hotel's draperies—à la the resourceful Scarlett O'Hara in *Gone With the Wind*.

Keynote speaker for the Congress was the deputy public affairs officer of the National Aeronautics and Space Administration in Houston. His topic was, appropriately enough, "Housekeeping in Space." Scale models of NASA spacecraft were exhibited in the Brown's lobby for the duration of the five-day conference.

For years, the Brown's executive housekeeper had her own little space among the stars in the heart of downtown Denver. Her rooftop patio was

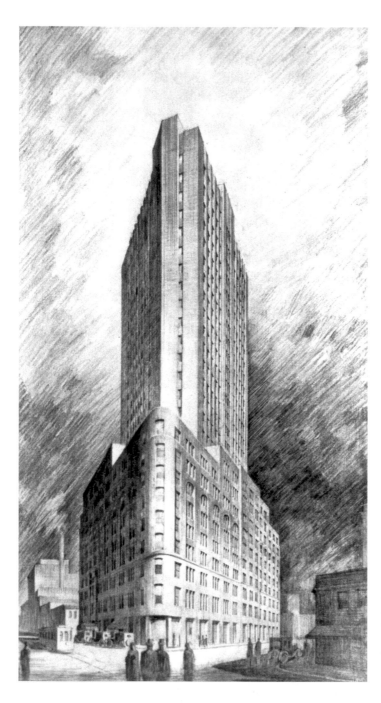

First plan
for hotel
expansion,
circa 1929, with
a nineteen-
story tower
rising from the
center atrium.

an out-of-this-world venue for warm weather parties. Rosalie planned get-togethers for up to twenty friends on full-moon nights to best showcase her incomparable sky-high location. Her hard work and dedication had landed her on top of the world.

The days of a live-in executive housekeeper at the Brown are long gone. The carpentry and paint shops, IT department, storage space and an employee meeting room occupy the uppermost level of the hotel. But one can still make out, amidst a labyrinth of air conditioning ductwork, the old screen door of Mrs. Soper's apartment and the patio nook that provided her well-earned retreat.

MARGE HARMON: GOING UP!

One young lady found much more than gainful employment when she began working at the Brown Palace in 1955. Marge Harmon found the love of her life. Bellman Eddie Harmon stole her heart, asked for her hand and fathered the four children of whom she is so proud. Their enduring romance began on the hotel elevators. "We had our ups and downs," she jokes, "but it's been a wonderful ride."

A friend who was off to college suggested that Marge apply for the position she was vacating. Thinking it might be a good way to earn money for school herself, Marge soon followed the advice and was hired as an "elevator pilot." Perched on a little fold-out stool in her blue uniform, she operated the elevator car with a hand crank, dutifully delivering guests to the floors of their choice. She delivered bellmen with cartloads of luggage, as well. Bellman Eddie made an especially big impression on the petite and pretty pilot. "I thought he was very good looking," she remembered. "I still do."

Besides its romantic possibilities, Marge loved her job for the wonderful panoply of people she got to meet. Be they obscure or prominent, most hotel guests treated her with respect and courtesy. She remembered the actress Rita Moreno as particularly warm and sweet, though not always impeccably groomed. Zsa Zsa Gabor "came in half-naked," according to Marge. "She was wearing a dress that barely covered her front and had nothing in back—at seven o'clock in the morning!" Only one celebrity struck a sour note with the elevator operator. Beloved actor Danny Kaye was not so loveable when he rode with Marge. "Don't you know who I am?"

Brown Palace elevator pilots Dorothy Tarr and Pat Dixon, 1957.

he asked indignantly when she tried to strike up a pleasant conversation. She knew, but she was not impressed by his superior attitude.

Marge remembered the Eisenhowers as among her finest passengers, recalling Mamie in her pillbox hats, "a lovely, gracious lady with a huge smile on her face." Their Secret Service escorts, on the other hand, could be "ornery." When they commanded Marge to "hold the elevator," she followed orders, no questions asked. Marge remembered clumps of agents

clustered around the Eisenhowers wherever they went. No one was allowed on the eighth floor of the hotel during a presidential stay without undergoing serious Secret Service scrutiny.

Instances of elevator malfunction were rare but did occur. Marge remembered the car getting stuck between floors on several occasions. The Otis Elevator repairmen were generally on-site, and she was well acquainted with them all. The most harrowing incident happened one morning when she had two Secret Service men and a little girl on board. Suddenly, the elevator plummeted out of control from the seventh floor. Marge hit the emergency button, and they jerked to a halt between the lower floors. The terrified child started screaming and wouldn't stop. When comforting words failed to calm the hysterical girl, Marge had to give her a firm but gentle slap. The agents seemed to think the whole incident funny, but Marge felt terrible about striking the child. She reported the incident to the manager on duty and apologized to the girl's parents, all of whom understood the necessity for her action. But for the rest of her extended stay at the Brown, that little girl took the stairs.

After dating for a year, impulsive nineteen-year-old Marge and thirty-one-year-old Eddie ran off to Raton, New Mexico, and were married on September 30, 1956. It wasn't long before they learned they were going to be parents. Eventually their family would come to include two sons, two daughters and six grandchildren.

Though Marge left the Brown Palace in August 1957 when expecting her first child, she was soon back in the workforce. Hired as a bookkeeper by the First National Bank, she moved up to "utility girl," floating between different departments whenever they needed someone to fill in for vacationing staff or extra help on projects. Promoted within a few years to a responsible position in the lockbox department, Marge spent thirty-four years with the bank, conveniently located just across Broadway from the Brown. Eddie continued to work as a bellman there, ultimately serving forty-three years.

Another Brown Palace elevator romance happy ending (Mr. and Mrs. Melvin Larsen) with Mrs. Soper's blessing, 1956.

Harmon was a favorite of the rich and famous who frequented the hotel, and he became something of a local legend.

Mr. and Mrs. Harmon retired on the same day—August 31, 1994. Marge went directly from her own 12:00 p.m. farewell party at the First National to the 2:00 p.m. send-off for Eddie at the Brown. Local television and radio crews focused almost exclusively on her husband, and Marge was quite content just to be by his side as he was showered with well-deserved attention and acclaim.

As empty-nesters, they traveled the world. At last the Harmons were able to enjoy the hospitality industry from the guest perspective, handing off their luggage to someone else and riding elevators that piloted themselves at the push of a button.

Not all hotel elevator romances had such happy endings. Divorced Denver socialite Jane Tomberlin was lunching at the Brown in May 1956 when she met Hawaiian prince Sam Crowningburg-Amalu on a Brown Palace elevator. Both declared that it was love at first sight. Prince Sam was a stylish international playboy, traveling with an entourage of questionable business associates and exuding cocky confidence. "He is a dashing, perfect gentleman," Jane told a *Rocky Mountain News* interviewer, "a wonderful dancer and possessed of a good sense of humor." Within a week, the lovebirds had arranged for a civil marriage ceremony and lavish reception to be held at the Brown.

The big day arrived, and so did Jane. But the groom was a no-show. Though she worried that he might have been delayed by an accident, Jane was sure that she would hear from him. Meanwhile, she entertained her friends as planned at a reception in the prince's suite.

Sam's call didn't come until the next day. He claimed he had been kidnapped by a relative who disapproved of the marriage. Prince Sam had not, it seems, yet received a final divorce decree from his first wife, a member of Italian royalty. Unconcerned by such details, Jane bought his story and welcomed her fiancé back with open arms. They immediately rescheduled their wedding and tied the knot in Colorado Springs, with a reception at the grand Antlers Hotel.

Less than a week into their honeymoon, the police came knocking and carted Sam off to jail for passing bad checks at both the Brown and the Antlers. Members of his entourage were also brought up on charges of forging securities and scheming to defraud several hotels.

Jane stood by her man. When she bailed the prince out for a second honeymoon, the Brown Palace sued him for $2,066.83. Reached for comment, Sam told reporters, "I can't understand what the 83 cents is for...I

Groom-to-Be Blames Delay on Family Opposition

Prince Sam Vows to Make Wedding Rite Next Time

By LEO ZUCKERMAN
Rocky Mountain News Writer

His Royal Highness Samuel Crowningburg - Amalu, the high chief Kapiikauinamoku of Hawaii, Prince of Keawe and Duke of Konigsberg broke loose from restraining family arms Thursday in Dallas to announce he was returning to the waiting arms of his Denver fiancee.

In Denver, open-armed Mrs. Jane Tomberlin, Denver and Honolulu society woman, who was left high and dry at the altar Wednesday with a wedding reception on her hands—and no groom—said she could hardly wait.

Both said the prince missed the wedding because he was kidnaped by a brother, who objected to the marriage.

"My family is making a very simple wedding ridiculous," prince, who prefers being called Sam, told United Press in Dallas. "It seems every time I marry a family disagrees."

"Who's getting married?"

Single Thought

Mrs. Tomberlin had been asking herself the very same question as she bravely carried on with the groomless wedding reception Wednesday and during some long hours Thursday.

The couple was to have been united Wednesday in the chambers of Denver Dist. Judge Albert T Frantz. The event would have coincided with the Hawaiian celebration of Independence Day — marking the Independence given many years ago to the islands by Queen Victoria.

"Not only is it Independence Day," said the prince in choosing the day, "but it is an auspicious date in my family. We celebrate several anniversaries and birthdays."

Exit Prince Sam

The prince left for Dallas on business Monday, right after announcing his impending marriage to The Rocky Mountain News. The couple met last week on an elevator in the Brown Palace.

A jubilant Mrs. Jane Tomberlin, Denver society woman, accepts some tardy explanation from her fiance, Prince Sam, via telephone from Dallas, Tex. —*Rocky Mountain News Photo by Bill Peery.*

Jane Tomberlin and Prince Sam. *Rocky Mountain News*, May 30, 1956.

don't like odd numbers." He concluded by calling the Brown management "poor sports."

Throughout the ensuing court proceedings, Jane remained devoted to her Polynesian prince. But when Sam was convicted and sentenced to four years in federal prison, Jane decided she had had enough. She filed for a quickie Honolulu divorce on grounds of mental cruelty and disappeared from the Denver social scene, without so much as an aloha.

KATHERINE RICKES ORR: AID AND COMFORT

Working mothers were still a rarity in the 1960s. But some women had no choice. When Katherine Rickes Orr divorced her alcoholic husband in 1964, she had to raise twin daughters with no financial assistance and little child-care help. Katherine was, however, fortunate in one regard. She had professional training. Her work as a registered nurse eventually

brought her to the Brown Palace, where she spent more than ten years caring for one of the hotel's last full-time residents.

Not everyone who worked at the Brown Palace was a Brown Palace employee. Some worked for the residents of the hotel's Skyline Apartments. An extremely prestigious and pricey address, the apartments housed some of Denver's most prominent personalities. From 1937 until 1980, it was the steady income from these well-heeled permanent residents that allowed the hotel operations of the Brown Palace to maintain a consistent level of elegance and excellence throughout the Great Depression, World War II and beyond.

Katherine Rickes Orr, 1946. *Courtesy Charlene Orr.*

Prior to the creation of the Skyline Apartments, much of the hotel's eighth floor was two stories high. In one forty-five-degree corner was the two-story Grand Ballroom/Banquet Hall. In the other was the two-story Ladies Ordinary, a sort of feminine clubroom providing a soaring lounge and dressing room. On clear days, two-story private dining rooms provided breathtaking views. The eighth floor was truly the crowning touch for architect Frank Edbrooke's Palace.

But during the economic hard times of the Great Depression, many grand hotels in Denver and around the nation began downhill slides from which most never rebounded. They deteriorated and declined, ultimately falling victim to urban renewal in the 1960s and 1970s. There used to be half a dozen upscale hostelries within blocks of the Brown—the Cosmopolitan, the Albany, the Shirley-Savoy—all gone now.

How did the Brown survive when so many others did not? The business-savvy C.K. Boettcher was at its helm. Never one to shy away from bold action, he realized that the times called for outside-the-box thinking. During the Great Depression, there was little call for big private balls or elaborate dinner parties. C.K. also recognized that many of Denver's wealthiest residents, including several personal friends and associates, had to tighten

their belts and downsize substantially. The owners of some Capitol Hill mansions, feeling the pinch, resigned themselves to renting out part or all of their homes and seeking other living arrangements.

Taking all these factors into account, Boettcher decided to convert the top two floors of the hotel into private residential apartments. A ninth floor had to be created where none had existed before. The massive remodel was complicated, disruptive and expensive. But C.K.'s gamble paid off with this early successful experiment in urban "mixed use."

Apartment 926 at the corner of Seventeenth and Broadway became home to Mr. and Mrs. Myron K. Blackmer, longtime members of Mrs. Crawford Hill's "Sacred Thirty-Six" social set. Mr. Blackmer's father, Henry M. Blackmer, had built his fortune in Cripple Creek freighting, railroading and, later, oil refining. It was the latter pursuit that brought the elder Blackmer's brush with infamy as a tangential player in the Teapot Dome scandal of 1923. Henry fled to France to avoid testifying before Congress and remained there in exile until 1949. In his absence, son Myron became vice-president of Midwest Refining Company and one of the West's preeminent oilmen. He moved with his wife, the former Eleanor Anderson of Colorado Springs, into the Brown in 1940.

When Myron Blackmer passed away in 1955, he left his widow well provided for. Their three grown children visited occasionally, along with three grandchildren. As she grew older, Mrs. Blackmer's general health deteriorated. Eventually, she needed around-the-clock professional care. She met Nurse Orr in 1971 while hospitalized and asked her to "come home" with her. Little did Katherine know at the time that home was the Brown Palace!

Katherine Orr's impressive résumé included a three-year nursing diploma from Vassar Brothers Hospital in 1947. She was one of 124,000 women (and a few men) who answered the government's call to alleviate the severe shortage of nurses during World War II. As a member of the U.S. Cadet Nurse Corps, she began her nursing career on the homefront. Certified by the Red Cross during the late 1960s, she met planes bringing wounded soldiers from Vietnam to Denver's Lowry Field and Buckley Air National Guard base. Her daughter Charlene often accompanied her mother, dressed in her own Red Cross pinafore and cap. The young teen helped by feeding the soldiers, many of whom had lost limbs or their eyesight.

As Mrs. Blackmer's private duty nurse, Katherine not only provided personal medical services but also supervised a small cadre of LPNs who stayed with Mrs. Blackmer when Katherine went home to her daughters.

Mrs. Blackmer's Skyline Apartment. *Courtesy Margaret P. Blackmer.*

But her duties didn't stop there. She ran errands, shopped for groceries and often cooked for the elderly woman. She took her to doctors' appointments and to have her hair or nails done in the Brown's own beauty salon.

The relationship between patient and nurse was that of employer and employee. Interactions were cordial but never overly familiar. Mrs. Blackmer clung to a time when class distinction was an accepted—and expected—reality. The rich were not like the working class. Thus, a society matron and "the help" might share a mutual respect, but they could never be equals.

Mrs. Blackmer clung also to the etiquette and refined customs that set her social tier apart from common people. In these things she was uncompromising. Though from a poor working-class background, Katherine knew how to behave graciously and performed all of her duties with the utmost dignity and discretion.

Katherine's daughter Charlene remembers only a few visits to the Brown Palace during her mother's years with Mrs. Blackmer. She and her twin sister Christine were old enough to drive and sometimes dropped off a grocery or

Nurse Orr and her twin daughters, 1950s. *Courtesy Charlene Orr.*

drugstore item with the bellman at their mother's request. They rarely went inside Mrs. Blackmer's apartment, but when they did, Katherine made sure that they were presentable. Pants on young ladies were, in Mrs. Blackmer's view, quite unacceptable.

Charlene recalls one occasion when Mrs. Blackmer took a personal interest in her affairs. Katherine told her employer that her daughter had been invited to the Air Force Academy Ball by a young cadet. Mrs. Blackmer immediately inquired what sort of corsage she planned to wear and was told that Charlene's escort always gave her pink tea roses. Mrs. Blackmer was adamant. Tea roses were all well and good for younger girls, but the AFA Ball called for nothing less than orchids. She promptly directed Katherine to phone the Brown Palace floral shop and to order just such a corsage for Charlene, who preserved the flowers for many years.

The always particular Mrs. Blackmer was not always cooperative. She stubbornly continued to smoke cigarettes, despite her dependency on oxygen. Her nurse fretted about the explosive fire danger, but the old woman would not hear of giving up her nicotine habit. The Brown Palace's "absolutely fireproof" claim must have been some comfort to Katherine, whose father had been a volunteer firefighter.

Working in the Brown Palace had its unexpected perks. One day Katherine met actor Van Johnson on the elevator. In chatting, the two discovered that they had something in common—twins! Every time Johnson stayed at the hotel, he made a point to look up the nurse and inquire about her daughters.

Over the years, the two women's relationship evolved. Mrs. Blackmer relied on Katherine always being there, and Katherine did not mind working many days in a row to get a little bit ahead financially. Mrs. Blackmer was reluctant to have strangers in her apartment. That included the ever-changing stream of LPNs who filled in when Nurse Orr was not on duty. Katherine expressed the hope that when Mrs. Blackmer passed away, it would be on her shift. And so it came to pass. In 1981, Eleanor Blackmer slipped away peacefully in the arms of her caretaker and loyal companion in apartment 926. The Blackmer family knew of the nurse's special connection to the departed and, out of respect, sent a limousine to Katherine's modest home in southwest Denver to chauffeur her to the memorial service in Colorado Springs.

On January 25, 2009, Katherine Orr concluded a lifetime of caring for others. Daughter Charlene Orr-Webb held her in her arms so that she did not have to face her final moments alone, just as Katherine had done for Mrs. Blackmer.

Around the time of Eleanor Blackmer's death, the Skyline Apartments were converted into the hotel's executive suites. Floors 8 and 9, now known as the "Top of the Brown," retain many of the Art Deco touches from the 1930s: terrazzo floors, rounded corners, glass brick enclosing the atrium and room doors with numerals that look like something on the *Queen Mary*. Mrs. Blackmer's former apartment is today's Teddy Roosevelt Presidential Suite, decorated in the rich Edwardian style of which Eleanor surely would have approved.

CORINNE HUNT: SAVING THE STORIES

Nothing less than a new word will do to adequately characterize Corinne Hunt: she was a historyteller. Whether she was writing a book or leading a tour, her work was as much about the narrative as it was about names and dates. Corinne understood that the personal anecdotes enmeshed within the Brown's past gave the hotel its distinctive place in history, as well as in hearts. Sharing these stories became both her job and her joy for more than twenty years.

A Kansan by upbringing, Corinne was a Coloradan by choice. She moved to Denver when her husband, Robert, was admitted to law school. She was soon fascinated by the state's colorful past. Corinne began leading tours of the city and the Front Range for Columbine tours and wrote for the *Colorado Travelers* series. Knowing of her passion for local lore, a friend who worked at the Brown mentioned to Corinne in 1966 that the general manager was looking for someone to pen a short brochure summarizing the hotel's history.

Corinne checked it out. A visit to the hotel was all it took for her to fall under its spell. Her timing was serendipitous. The brochure grew into a book, *The Brown Palace Story* (1982), which grew into a revised centennial edition (1992) and, finally, into a gorgeous, full-color coffee table tome, *The Brown Palace: Denver's Grande Dame* (2003). In the midst of it all, she joined the staff as hotel historian in 1977 and was appointed the first director of public relations two years later. Rare is the hotel with a dedicated historian, especially in the relatively new Rocky Mountain West. But management recognized that it was the history that made the Brown unique among Denver hotels.

No hotel archives existed when Hunt came on board. Old guest registers, architectural blueprints, scrapbooks, menus, photos and ephemera were haphazardly stored in boxes, cabinets and dusty corners throughout the hotel. Corinne began pulling it all together as she undertook research for her books. She finally convinced her boss of the need for a central repository for

Corinne Hunt (center) with associate historical guides Julia Kanellos (left) and Jenna Robbins (right) on the Brown's Grand Staircase, 1997. *Courtesy Jenna Robbins.*

the precious primary source materials. An out-of-the-way space was cleared out for that purpose, and Hunt began the daunting task of organizing an archive from scratch.

A previous "biography" of the Brown had been published in 1955. *The Brown Palace in Denver: Hotel of Plush, Power and Presidents* was one in a popular

series of booklets on Colorado history written by Caroline Bancroft in the 1940s and 1950s. Bancroft's allegedly nonfiction tales of Colorado's colorful characters, including Margaret "Molly" Brown and "Baby Doe" Tabor, spawned simplistic misrepresentations that serious historians are still trying to correct in the public mind. By and large, Bancroft did a creditable job with the Brown's story. Still, with access to original hotel documents and artifacts, Corinne knew that she could do much more—and proved it, with not just one but three books. Her reputation as the Brown's "institutional memory" was well deserved.

Historian Hunt also initiated complimentary historical tours of the Brown for the public. Incorporating history, architecture and personalities, Corinne's guided talks not only engaged her audience but also enlightened and entertained. Word spread, and her twice-weekly tours soon became known to both locals and visitors as one of the best freebies in Denver. Corinne also offered private tours for all sorts of interested groups, from schoolchildren to senior citizens.

Tour guests invariably wonder about the mythological griffins (or gryphons) that adorn the hotel's logo and décor. These half-eagle, half-lion creatures are said to be the guardians of treasure, and the Brown Palace certainly qualifies. More specifically, griffins are the protectors of mountain gold, in plentiful supply in Colorado at the time the hotel was built. Rumors suggest that an actual golden treasure was buried beneath the building during the hotel's construction—a treasure that its griffins have been guarding ever since. Though there is no evidence to support this theory, the intriguing speculation could explain the storied beasts' omnipresence in the Brown.

As the original hotel historian and archivist, Corinne Hunt was something of a griffin herself, zealously preserving irreplaceable treasures from the Brown's past. Somehow she also found time to write *The Elitch Garden Story: Memories of Jack Gurtler* (1982) and *Historic Inns and Hotels of Colorado* (1989). After

Mythological griffin on Brown Palace elevator door. *Courtesy James Faulkner.*

retirement in 1997, she continued to write on a freelance basis. She served as historian for the Colorado Business Hall of Fame and was active in the Denver Woman's Press Club. Corinne also conducted tours of the Grant-Humphries Mansion and volunteered with the Colorado Historical Society, where she worked one day a week indexing scrapbooks. On her travels, she always took local historical tours, which she admitted she could not resist critiquing.

Though she confidently entrusted the historian job to her successors, Hunt was so invested in the Brown that she may never leave entirely. "I'm coming back as a ghost when I die," she once joked to a *Denver Business Journal* reporter. It will surprise no one if she does.

BARBARA GOODRICH: A VARIED REPERTOIRE

One of the biggest challenges for an in-house musician is to develop a repertoire large enough so that regular guests and other employees don't hear the same pieces over and over again. Keeping the music fresh takes innovation and imagination. The task is particularly daunting for a harpist, as not much has been written specifically for the harp. For nearly fifteen years, Barbara Goodrich met the challenge masterfully and enhanced the Brown Palace Afternoon Tea experience for countless guests.

Music has filled the hotel since the beginning. A string quintet played in the Ladies Lounge at the turn of the last century. Since the reinstatement of Afternoon Tea service in the soaring atrium lobby in 1986, alternating piano and harp musicians have provided a living soundtrack for the daily four-hour affair.

When Barbara first set up her harp in the Brown Palace lobby in 1995, she made building a large and varied repertoire a priority. "Like many harpists, I've looted piano repertoire, opera, pop, rock, Sinatra—you name it," she confessed. "I'm shameless."

She delighted in subverting the stereotype of harp music as "angelic." Her childhood inspiration, Harpo Marx, was certainly no angel, but he made playing the instrument look like great fun. From the age of seven, Barbara played with that same delight. One of her favorite compliments while playing at the Brown Palace came from a guest who thanked her for her unique approach. "You know, this is the first time I've heard harp music that was not at all saccharine."

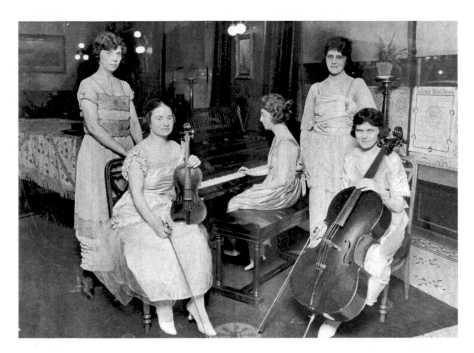

String quintet at the Brown, circa 1910.

Barbara played classical and operatic music, Viennese waltzes and movie themes. With unexpected selections like "That Old Black Magic," Ravel's "Bolero," "A Whiter Shade of Pale," "Hit the Road, Jack" and Guns N' Roses' "Sweet Child o'Mine," Barbara shook up preconceptions about harp repertoire. Often listeners would recognize that the tunes were familiar, but they couldn't quite identify them because they sounded so different on the heavenly instrument.

As the Brown Palace harpist, Barbara always had "Happy Birthday," "The Wedding March," "Anniversary Waltz" and "Pomp and Circumstance" at the ready. But she looked forward to holidays and special occasions as opportunities to pull out appropriately themed pieces. Christmas music was easy to find, and St. Patrick's Day lent itself to all sorts of Celtic harp tunes. Halloween called for Bach's "Toccata and Fugue," selections from the Harry Potter films and a section from Orff's *Carmina Burana*, which she called "the best horror film music ever." She looked forward to April Fool's Day as the chance to play "all the stuff I usually tell myself not to—Led Zeppelin, Pink Floyd and such."

The harps she played were her own. The gold one she had since childhood held a special place in her heart. She generally kept it at the Brown to keep

from having to carry it back and forth from home. On occasion, she had to load it into the service elevator and up to one of the "Top of the Brown" executive suites to play for a private party.

Though she trained at Brown University's famed Tanglewood Institute and performed professionally since high school, the harp was not her greatest passion. Barbara was bitten by the philosophy bug and moved to Colorado to accept a doctoral fellowship at the University of Colorado in Boulder, where she completed her PhD in the mid-1990s. Who would have suspected the quiet woman plucking the harp strings to be a bona fide university professor? Her extensive interests included neuroscience and philosophy of the arts, psychology and animal behavior.

Barbara Goodrich in the Brown Palace atrium lobby. *Courtesy Barbara Goodrich.*

Like many Brown Palace associates, Barbara sometimes rubbed elbows with celebrities. Though usually cool about such encounters, she found herself tongue-tied in the presence of fellow artist and academic Maya Angelou. "I did feel like a schoolgirl shaking her hand." During the 2008 Democratic National Convention, Barbara was impressed by two well-mannered young girls who inquired about her harp and asked permission to touch it. She was happy to explain the strings and pedals and even showed them how to play glissandi. Only later did she learn that the polite and enthusiastic youngsters were granddaughters of Senator Edward Kennedy, a guest of the Brown during the DNC.

Add animals to the list of Barbara's passions. Over the years, she enjoyed the many pets hotel guests brought along with them. Whenever someone strolled through the lobby with a nice dog on a slow day, Barbara would join the rest of the tea staff in swarming out and cooing over the animal. She recalled one dog in particular, "the most gorgeous dog I've ever seen, walking serenely with deer-like grace alongside an elegant women into Churchill's." Barbara stopped playing mid-song and followed them into the hotel's cigar bar. She asked about the beautiful creature and learned that it was a very well-trained borzoi, which "graciously greeted me like sweet-natured royalty."

In light of her enchantment with animals, it should come as no surprise that Barbara retired from music and her Brown Palace engagement in the fall of 2010 to enter the veterinary program at Colorado State University—which she insisted is a sort of applied philosophy. In her personal and professional life, as well as in her music, Barbara Goodrich's impressive repertoire was indeed varied. She was, in every way, a hard act to follow.

Part V

Prominent Ladies

Queen Marie of Romania: A Royal Ruckus

America was mad for celebrities in the Roaring Twenties, from sports figures to movie stars, aviators to royalty. Queen Marie of Romania fanned the flames when her 1926 railroad trip across the country gave an estimated six million people the chance to gawk at Her Royal Highness. Her two-day stop in Denver was a highlight of the popular monarch's transcontinental trek. The illustrious Brown Palace, accustomed though it was to hosting the rich and famous, would long remember Queen Marie's breeze-through as one of its finest moments.

Marie was Romanian by marriage only. A granddaughter of both Queen Victoria and Czar Alexander II, she was born in England in 1875 to Albert, Duke of Edinburgh, and the Grand Duchess Marie of Russia. As Princess Marie, before wedding Prince Ferdinand of Romania, she met American railroad millionaire and world traveler Sam Hill in Europe in 1893. Their unlikely friendship led Hill to invite her years later to officially dedicate his Maryhill Art Museum on the Columbia River in Washington state. Though she had in the interim ascended to become Queen Marie with her husband's 1914 coronation, she accepted Hill's invitation without hesitation, having foreseen a trip to America in a recent dream. It presented an opportunity to raise money for her country, economically depressed by World War I, and perhaps a little cash for herself, as well.

As the first queen ever to tour America, Marie was adored by the sycophantic public. From the moment she swept off the ocean liner in New

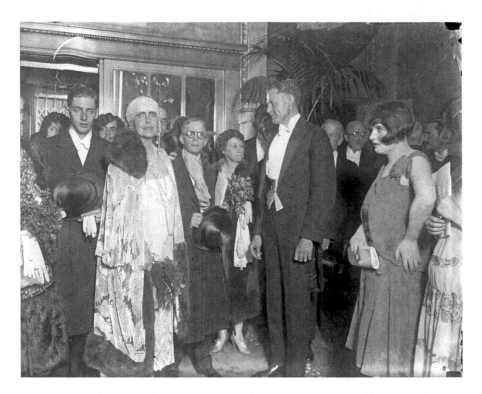

Queen Marie of Romania in the Brown Palace lobby. *Courtesy Denver Public Library, Western History Collection.*

York City, she was featured in parades, greeted by dignitaries, chauffeured to local landmarks and honored at regal receptions. She crisscrossed the country in a special ten-car luxury train, accompanied by an entourage of eighty, which included reporters and photographers, hairdressers, servants, cooks and stewards. Two of her six children, Prince Nicholas and Princess Ileana, and royal spaniel Creki rounded out the expedition party.

Among the reporters on board the *Royal Romanian* was a former *Denver Post* ace, Gene Fowler. He had moved onward and upward to scoop for legendary publisher William Randolph Hearst in New York. Rumor had it that the rakish thirty-two-year-old press star captured the heart of the fifty-one-year-old queen with his devilish charm. King Ferdinand, it seems, had always been a sickly sort, and scandal was no stranger in the court of the lusty and liberal-minded Marie.

After royally launching Hill's unfinished museum in Washington, Her Royal Highness reboarded the train for a journey across the American

West. Whether it was Fowler's influence that put Denver on Queen Marie's itinerary, the world may never know. Her train arrived at Union Station early that December morning. The twenty-one-gun salute delivered by the Colorado National Guard surely roused the few still in bed instead of at the depot to greet the royal guest. The official welcoming committee included Denver mayor Ben Stapleton and Governor Clarence Morley.

First on the queen's Denver agenda was a parade through downtown to City Auditorium, where fourteen thousand cheered her appearance and short speech promoting world peace. Then the group motored up to Lookout Mountain and the grave of legendary Buffalo Bill Cody, whom Marie had seen in her youth at thrilling Wild West Show command performances for her grandmother Victoria. Luncheon at Charles Boettcher's 1917 hunting lodge atop the same mountain was a predictably grand affair, made awkward only when Creki escaped Princess Ileana and "marked" a leg of the Boettcher Steinway grand piano as his personal territory.

With no time to tarry, the tightly booked queen was next chauffeured to the Denver Dry Goods department store downtown, where she spent an hour or two personally endorsing the new Hoover Suction Sweeper. Her stamp was gold to American advertisers. Daring flappers took note when cigarette ads declared: "Queen Marie says, 'It's better to reach for a Lucky instead of a sweet.'"

Somehow she managed, despite peddling products, to retain an air of aloofness. For her arrival at the Brown Palace the evening of December 10, 1926, nothing less than a special entrance was created on the Tremont Street side of the building so that Her Royal Highness could pass directly from her limousine to the elevators without coming into contact with the commoners thronging the hotel. Red carpet was laid from the curb to the lobby. The entire eighth floor was reserved for Queen Marie and her sizeable party to dress for dinner. Mr. and Mrs. Horace Bennett (co-owner of the Brown at the time) were honored to surrender their personal

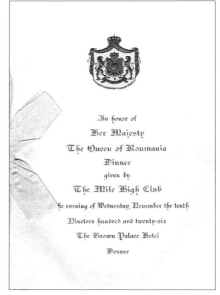

Queen Marie dinner program. *Courtesy Joan Edwards.*

117

suite to the queen and her daughter. Mrs. Bennett left several of her personal items for the royals' use in preparation for that evening's banquet.

The Mile High Club proudly served as an elite welcoming committee for all prominent visitors who passed through the city. Other guests entertained by Denver's Fifty Families, as they were also known, included President Warren G. Harding, Herbert Hoover and Roald Amundsen. The Brown banquet staff put on an event worthy of royalty in the two-story eighth-floor Grand Ballroom. The menu presented three hundred guests with giant asparagus hollandaise, Colorado mountain trout amandine and breast of guinea chicken theodora. When the queen at last tired of toasts and speeches, she was whisked off to her luxurious private rail car and bed.

Before departing Denver, Queen Marie met with schoolchildren in City Park. She lavishly praised the Denver police for not only for their efficiency and courtesy but also for their good looks.

Neither Marie nor Gene Fowler ever spoke of how they passed the long hours on board the train during her seven-month American sojourn. But on several occasions when she was a no-show for scheduled rear-platform appearances, the reporter was curiously missing as well.

The Romanian queen was only the first in a continuing line of international royals to visit the Brown. The impressive list includes Russia's exiled Princess Stephanie; William, Crown Prince of Sweden; Prince Frederik and Princess Ingrid of Denmark and Iceland; Emperor Akihito and Empress Michiko of Japan; and Great Britain's Princess Anne, Andrew the Duke of York and the popular Duchess of York, Sarah Ferguson.

The most recent royals to stay at the Brown live in customized quarters on the roof. Three queen bees reign over urban honeybee colonies, each begun with twenty thousand workers and ever growing. The honey harvested from these busy guests is used in signature pastries served at Afternoon Tea and in special Brown Palace Spa treatments. From more than 280 entries in a contest to name the hotel's rooftop hives, the winners selected were "The Mile Hive City," "The VIBee Suite" and "Buzzingham Palace."

Brown Palace Urban Bee Initiative.

Mamie Eisenhower: Hometown Girl

The epitome of the respectable 1950s wife, Mamie Eisenhower wore pearls, furs and bangs. Though her birthplace of Boone, Iowa, lays claim to her, Mamie Geneva Doud was actually a Denver girl. She grew up in a "Denver Square" at 750 Lafayette Street, where her mother, Mrs. John S. Doud, lived out her later days. During Dwight Eisenhower's presidency, "Ike" and First Lady Mamie often spent as long as eight weeks at a time in the nearby Brown Palace, earning the hotel the unofficial title of "Western White House."

Mamie met handsome young second lieutenant Dwight David Eisenhower on a family autumn trip to Texas. After a suitable period of courtship, Eisenhower proposed marriage to the lovely young lady from Colorado. They announced their engagement on Valentine's Day 1916. Her father objected initially, thinking his little girl too young for wedlock at the tender age of nineteen. But true love prevailed, and the Eisenhowers tied the knot in the parlor of the Doud home on July 1, 1916.

As a young army wife, Mamie soon came to long for the privileged life of her upbringing and the stability of a regular residence. She could count thirty-four moves in the first decades of her marriage—seven in one year alone. Wherever she found herself—from Panama to Paris to the Philippines—she did her best to create a comfortable home where friends felt welcome. It was always a challenge.

Early in their marriage, Ike made his priorities crystal clear. His duty to country would always come first, he told Mamie. His duty to her was secondary. It was a sobering truth she would have to accept in order to make their relationship last.

The Eisenhowers' first son arrived in 1917. Doud Dwight, whom Mamie called "Icky," succumbed to scarlet fever before he turned four. Her devastation at the loss was so profound that it seriously threatened their marriage. But eighteen months later, she gave birth in Denver to a healthy second son, John Sheldon, who ultimately followed in his esteemed father's footsteps as a West Point cadet and commissioned officer.

The U.S. entry into World War II saw Ike promoted to major general. His appointment as supreme commander of the Allied forces on the European front separated him from Mamie as never before. Any knowledge of his whereabouts or undertakings could jeopardize the plans and the security of the Allies. Mamie endured an interminable period with scant information about or communication from her high-ranking husband. Like the rest of

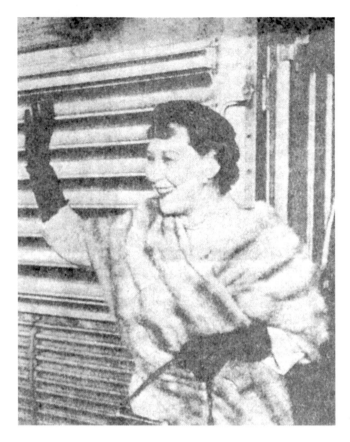

Mamie Eisenhower arrives in Denver to visit her mother. *Rocky Mountain News*, May 13, 1959.

the nation, she learned about his D-Day invasion of Nazi-occupied France from the radio.

Mamie knew during these trying war years about the young woman who shared General Eisenhower's daily life in Europe. His attractive British chauffeur, Kay Summersby, was his constant companion and confidante. Rumors that their relationship became more intimate than professional surely tormented an anxious Mamie waiting at home. When the war ended and she and Ike were reunited after three long years, Mamie asked him point-blank about his feelings for Summersby. He vehemently denied any infidelity, and no substantive evidence, including Summersby's own memoirs, has ever surfaced to the contrary.

Almost before the reconciled Eisenhowers could catch their breath, a country crying out for postwar leadership drafted Ike to run for president on the Republican ticket in 1952. He commandeered as his election campaign headquarters a large corner office space on the second floor of the Brown

Palace, later the Brown Palace Club. His wife was a natural campaigner, impressing the public with her warm and friendly manner wherever she spoke on her husband's behalf.

With his sterling war record, reassuring smile and catchy "We Like Ike" slogan, Eisenhower easily defeated Democratic candidate Adlai Stevenson in a landslide victory. In 1953, Mamie found herself setting up housekeeping in yet another new home—1600 Pennsylvania Avenue in Washington, D.C. She ran the White House with the efficiency of a military wife and was known especially for her flair as a hostess. Mamie soon put her own stamp on the role of First Lady.

When in Washington, the Eisenhowers tended to be homebodies. But they traveled frequently to Denver on military business, to visit Colorado governor Dan Thornton and his wife Jessie and to spend time with Mamie's mother. When in town they stayed at the Doud home, Lowry Air Force Base or the Brown Palace Hotel.

The Brown boasts that every U.S. president since Teddy Roosevelt in 1905 has visited the hotel, with the exception of Calvin Coolidge, who never traveled to Colorado. Eisenhower spent more time in the Brown than any other commander in chief. Ike loved to golf and fish, both outdoor activities for which Colorado is ideal. One of the best-known stories about Ike and the Brown involves an incident when he nicked the presidential suite's fireplace mantel while practicing his golf swing indoors. The damaged mantel was, of course, replaced with subsequent redecoration of the suite. But a piece of it was preserved in a shadowbox with an explanation, so that visitors can still see the presidential dent.

The Brown's executive chef, Ira Dole, often accompanied Ike on fishing trips during his Colorado visits. Their shared passion inspired Dole to create a special ice sculpture for one of the Eisenhowers' in-suite dinner parties. The sculpture featured mountains with real snow on top, a miniature lake with a small fishing boat and tiny live baby trout swimming in the lake. During the course of the evening, one of the fish somehow managed to flip out of the water and onto the floor. In his haste to rescue the little creature, Ike nearly upset the entire table.

Eisenhower's soft heart was also apparent in his tenderness toward Mamie. Whenever they planned to stay at the Brown, he called ahead and arranged to have the presidential suite filled with her favorite flowers—red-speckled Colorado white carnations.

Mamie's role as First Lady was strictly a supporting one. She was not allowed by West Wing staff to hold her own press conferences or to express

support for political causes or organizations. In line with the parameters for middle-class, middle-American wives of the 1950s, she was expected to entertain, dress nicely and oversee the household budget—and little else. She maintained a close connection with the public through extensive personal correspondence and occasional articles for women's magazines. Unofficially, her husband often sought her views on difficult issues, respecting her judgment, fiscal sense and instincts.

The national spotlight shone on Denver in September 1955 when Ike suffered a massive heart attack at the Doud home after playing twenty-seven holes of golf. He received the best of care at Fitzsimons Army Hospital and later recuperated at the Brown with Mamie constantly by his side. Chef Dole customized menus that incorporated the president's new dietary restrictions without compromising taste. The famous beef tenderloin dish Dole had earlier created especially for Ike was served but sparingly from then on.

The Brown's original presidential suite, in the ninety-degree corner on the eighth floor, is today named in the Eisenhowers' honor. Of course, it looked quite different in their day. The living room was paneled in knotty pine, and twin beds reflected the preference of the times. A hotel brochure from the Eisenhower decade promised a premier experience:

> *Expectancy stands on tiptoe as you are ushered into the Presidential Suite. In every pleasant sense, it is an "adventure coup" that the Brown Palace offers you as its exclusive own. Throughout all the luxurious rooms there is an atmosphere of tasteful simplicity and relaxed comfort.*

In 2000, two additional presidential suites were added to the "Top of the Brown." The designers selected two presidents with lifestyles representing distinctive periods of western history upon which to base the décor in the new suites. The Teddy Roosevelt Suite evoked the Edwardian era of the early 1900s, with dark wood wainscoting and wilderness and wildlife touches referencing TR's enthusiasm for both hunting and conservation. The Ronald Reagan Presidential Suite was done in a California ranch theme, with mission-style doors, adobe-like wall treatments, leather furniture and wrought-iron fixtures. These suites occupy the forty-five-degree corner at Seventeenth and Broadway. A proposed fourth presidential suite, honoring John F. Kennedy, never got off the launch pad.

After two terms in the White House, the Eisenhowers retired to a farm in Pennsylvania, where they enjoyed their first permanent home and regular visits from their grandchildren. Mamie's Colorado legacy includes

Top: Eisenhower Suite in the 1950s.

Bottom: Eisenhower Suite, 2010.

a University Hills neighborhood park in Denver County and a Broomfield public library named in her honor. Patrons describe the Mamie Doud Eisenhower Library as very bright, cozy and friendly. "You have a feeling that you are at home," wrote one reviewer. Fittingly, it was just such an atmosphere that Mamie strove to provide wherever she went, as an itinerant military wife or as one of America's most admired First Ladies.

JESSIE THORNTON: EQUAL PARDNER

She was tougher than she looked. No one, including her future husband, would have mistaken willow-thin, fair-skinned Jessie Willock for the outdoorsy type. But she proved herself not only a capable ranchwoman but also a resilient Colorado First Lady. She and Dan Thornton frequently stayed and briefly lived at the Brown Palace, where they also began one of the hotel's most distinctive traditions.

Texas-born and raised Dan Thornton met physics student Jessie on the University of California–Los Angeles campus. He was immediately struck by her spirit, as well as her delicate beauty. Within a week, they were engaged. They married in a quiet garden ceremony in the Willock family's Pasadena backyard on April 7, 1934.

Dan, who had been attending UCLA on a football scholarship while majoring in political science and business administration, dropped out of school to make a living for the newlyweds. His work in butcher shops and feed yards built on his earlier studies in animal husbandry at Texas Tech.

When Jessie was afflicted with a type of tuberculosis, the young couple moved to a Palm Springs, California dude ranch for the fresh, clear air. Though he never asked her to help him raise cattle, it was clear to Jessie that livestock was Dan's passion. As soon as she recovered, she suggested that they become ranchers. With $800 Dan had saved from earlier oil field work, they began to shop for a property in the dry southwestern clime that doctors recommended for Jessie's health.

They found a place outside Springerville, Arizona. With a sizeable loan from Jessie's father, Curtis M. Willock, they started the White Mountain Ranch and began to stock it with registered purebred Hereford cattle from cattle breeders around the West. Dan recognized superior stock when he saw it and traveled extensively to procure the finest. Soon the White Mountain Ranch was renowned for its exceptional Herefords.

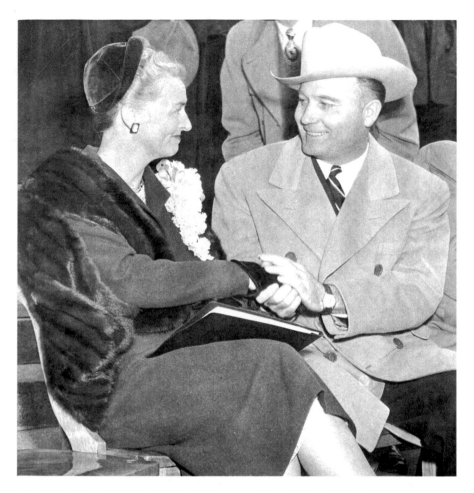

Jessie and Dan Thornton. *Courtesy Denver Public Library, Western History Collection.*

Jessie took to ranch life. Although raised in a wealthy family, she was not averse to hard work. She fed and supervised as many as twenty-five cowboys at a time. She rode out among the herd on her horse, Old Red, and knew all of the cows.

After completing a course in agricultural accounting at a local college, Jessie kept the ranch books and maintained records of the operation. She found it all fascinating. A helpmate in every sense, Jessie was Dan's equal partner in their cattle business. She sometimes traveled with him and their show herd to stock shows in which their animals brought consistently high prices and industry acclaim.

Jessie loved the White Mountain Hereford ranch and might have happily lived there forever. But "Driftin' Dan" was always looking for greener pastures. When he traveled to Gunnison County, Colorado, to judge a 4-H show, he decided that he had found their next home. In December 1941, just six days before the United States entered World War II, the Thorntons moved to their new ranch on Colorado's western slope.

The annual National Western Stock Show was the highlight of the year for livestock breeders who came to exhibit and auction their best animals. Thornton Herefords had for years dominated the awards. But in 1945, two of their champion "Triumphant Type" bulls—father and son—made national news by auctioning for an unprecedented $50,000 each. Dan was featured, sporting his trademark Stetson, pipe and boots, with T.T. Regent and T.T. Royal Regent in both *Time* and *Life* magazines.

The Thorntons counted among their Colorado friends C.K. and Edna Boettcher, owners of the Brown Palace Hotel, where Dan and Jessie always stayed during the stock show. At the Boettchers' request, Dan escorted his champion bulls into the hotel's atrium lobby for photographs. The hefty Hereford superstars calmly waddled in on a red carpet usually reserved for royalty and courteously posed for a couple of hours until the heat became too uncomfortable for them. Brown Palace manager Harry Anholt reported that they behaved as perfect gentlemen.

The spectacle brought the hotel such notoriety that it soon found itself turning away guests. One disgruntled stockman was heard to grumble during the Hereford exhibition, "Good gosh, I can't get a reservation in this hotel, but a bull can."

The Grand Champion Steer still holds court in the lobby of the Brown each January at the end of the National Western. He settles into a temporary pen right next to the ladies taking Afternoon Tea in their hats and gloves. He drinks from a silver punch bowl and wears a garland of flowers around his neck. The general public is invited to have complimentary photos snapped with the number one steer. For decades, it was customary for the Brown to then purchase the steer and serve him up in the hotel restaurant for those inclined to meet and eat him.

In 1948, Dan entered politics when he was elected state representative from Colorado's eleventh district, encompassing three western slope counties. Two years later, when the Republican candidate for governor, Ralph L. Carr, died suddenly just a month before the election, Dan was drafted to run in his place. Conducting a blitzkrieg of a campaign by flying all around the state, Dan's competitive spirit, straightforward manner and confident smile won over

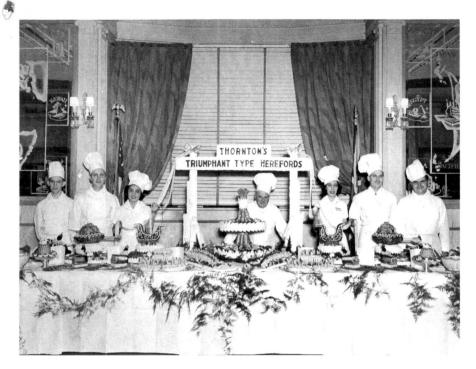

The Grand Champion Steer is served!

voters. When he was sworn in as Colorado governor just short of his fortieth birthday, his shy wife found herself suddenly thrust into the public eye.

Jessie had always been comfortable working behind the scenes, but she embraced her new role as the governor's wife. The press and the public liked the way she exemplified both western toughness and ladylike qualities. A *Rocky Mountain News* reporter who interviewed Mrs. Thornton at the Brown wrote: "She's the kind that sits back and bolsters others by letting them have the floor...the kind of lady who can take everything gracefully in stride. No doubt but what she will be one of the most popular First Ladies of Colorado to date."

Dan and Jessie lived at the Brown during the campaign and while they looked for a house to lease in Denver. Colorado at the time provided no executive residence. Not until Edna Boettcher bequeathed her own home to the state for a Governor's Mansion was the situation corrected.

The Thorntons were the official Colorado hosts for President and Mrs. Eisenhower. Dan had campaigned vigorously for Ike's election, and the two couples became personal friends, as well as political allies. Dan was Ike's golf

and fishing buddy whenever the president visited. Their camaraderie was likely a factor in Eisenhower's selection of Colorado Springs as the site of the new Air Force Academy in 1954.

The Thorntons often delved into their own pockets to promote Colorado products and tourism. After a remarkable two-term tenure as the state's chief executive, Dan announced in 1954 that he would not seek reelection and would return to private life. The Thorntons leased the Brown's five-bedroom Skyline Apartment 853 while they contemplated their next move. It was at the Brown Palace in 1957 that the emotional Thorntons announced that they were selling their Gunnison ranch.

Jessie missed ranch life—meals with the hands in the cookhouse, the little Hereford calves and the wide-open spaces. But she was still a "city girl" at heart. She and Dan purchased a new home in Denver's Cherry Hills with the gift of $150,000 from Jessie's mother, Mary S. Willock.

When Jessie Thornton passed away the day before Christmas 1972 after a long battle with breast cancer, she left an estate worth more than $1 million, plus substantial royalties from oil and gas wells. With no children of her own, Jessie chose to invest in the future of the ranching industry she loved by endowing Texas Tech College, Western State College in Gunnison and Colorado State University. Her gifts established funds to assist students, faculty and researchers working in animal science, biology, veterinary medicine and agricultural economics programs. Thanks to Jessie's generosity, needy students with a hankering for living on the land have been given a chance to make it on their own terms, just as she and Dan did in their early years.

MARILYN VAN DERBUR: MISS AMERICA BY DAY

She seemed too good to be true. With the face of an Ingrid Bergman, the brains of a Rhodes scholar and the poise of a monarch, Marilyn van Derbur burst into the limelight in 1958 as the first Miss Colorado to be crowned Miss America. From the moment of her 1956 presentation at the Brown Palace as one of Denver's earliest debutantes, she appeared destined for great and wondrous things. But behind the beauty queen smile lurked an unspeakable secret that rent Marilyn in two and jeopardized her emotional health and happiness.

As an East High School "Angel," Marilyn van Derbur defined overachiever. The straight-A student who excelled at swimming, golf, skiing and horseback

riding was the model of the western all-American girl. She was invited to pledge Pi Beta Phi when she enrolled at the University of Colorado in Boulder. But sorority life was never a fit for the essentially shy Marilyn, who avoided campus parties and football games.

The lovely Miss Van Derbur was exactly the sort of admirable young woman the Denver Debutante Ball committee sought to represent the cream of the city's best families. Marilyn's maternal grandfather was none other than the Olinger who founded Olinger Mortuaries. Her father, Francis van Derbur, later succeeded him as president.

Marilyn, the youngest of four daughters, won every competition she entered, from *Seventeen* magazine's Miss Young America to Miss CU at college. She learned her social graces as one of the 1956 "debs." Usually considered a southern custom, Denver's Debutante Ball evolved from the annual Symphony Ball fundraiser and still raises money for the Symphony Association. As long as the charitable elite were dressing up, why not make it a "coming out" party for the eligible daughters of wealthy and socially prominent families?

Marilyn was presented with eleven other debs in the Brown Palace. Gliding one by one down the elegant Grand Staircase, each girl was met by an escort and handed off to her father for the first waltz. With the original eighth-floor ballroom converted to apartments and the new ballroom across Tremont Street not yet constructed, the young ladies in white formals danced the night away in the hotel's exquisitely decorated atrium lobby.

The Debutante Ball tradition continues at Christmastime each year and is the largest annual event hosted by the hotel. Little has changed over the years, and that is much of its charm. A holiday tradition for many prominent Denver families, every "class" sees more third-generation debs than the previous, as well as young women from families never before included. Over the years, it has transformed from a showcase of desirable marriage candidates into a networking opportunity for up-and-coming local philanthropists and public figures.

In Marilyn's day, the ball was something of a bachelorette bazaar. But it was also an entrée into womanhood and a showcase of etiquette. The experience served her well as she progressed just two years later from Miss CU to Miss Colorado and finally Miss America. There she was, "your ideal," as pageant host Burt Parks crooned in the traditional ballad, while the newly crowned beauty queen smiled through the television camera into living rooms across the county. Marilyn's life was about to change dramatically.

Her hectic schedule of public appearances and speaking engagements began the day after the pageant and never let up during her yearlong reign.

12 Denver Debs Make Their Bow at Symphony Ball

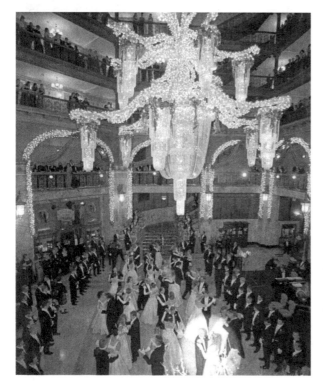

Above: Denver Debutantes of 1956, with Marilyn van Derbur on far left. *Rocky Mountain News,* December 30, 1956.

Left: Denver Debutante Ball in Brown Palace atrium lobby, 2002.

When panic attacks threatened to debilitate her, Marilyn kept sight of the fact that, as Miss America, she was not allowed personal problems. The role demanded that she represent the pageant organization by performing all that was required with composure and wholesome charm. Marilyn met those demands with a style equaled by few who have held the title.

One of Marilyn's favorite responsibilities as Miss America in 1959 was official hostess of the "Rush to the Rockies" centennial. Coloradans went all out to celebrate the state's gold rush origins. Even the most conservative businessmen grew prospector beards to show their pioneer spirit, and collectible glasses, plates and trading cards portrayed pivotal events of the "Pikes Peak or Bust" era. The Brown Palace found in the centennial a perfect Old West theme for the inaugural event launching its new Grand Ballroom. The sumptuous state-of-the-art venue occupied the entire second floor of the new twenty-two-story tower annex across Tremont Street. The Brown Palace West, as it was originally called, added nearly three hundred rooms to the hotel's inventory to meet the demands of a growing city and a burgeoning tourist trade.

Marilyn van Derbur leveraged her reign as Miss America into a successful motivational speaking and television career. She was named Outstanding Woman Speaker in America by the National Speakers Association and hosted many TV shows. But her attractive public façade masked a terrible inner torment.

She revealed it first to a former youth minister from her church. He was living in California when she stopped in Los Angeles to do some filming. He had long suspected that Marilyn kept a private agony buried deep inside while setting such high standards for herself. At twenty-four, she finally shared her pent-up shame with this trusted confidante. From the age of five until she was eighteen, Marilyn had been sexually molested by her own father.

To cope, she had split her fragile persona into two psychological entities: a "day" girl who basked in the light of confidence and accomplishment, and a "night" girl, mired in dark dread and betrayal. The revelation was only the beginning of a long and agonizing process that finally enabled her to reconcile the two aspects of her personality and begin to heal.

Marilyn did not have to face the ordeal alone. Since her sophomore year in high school, her heart had belonged to Larry Atler. Fear of the truth being exposed and of his condemnation had led Marilyn to break off their relationship time and time again. But when at last she bared her soul and told him everything, Larry could not have been more understanding and supportive. They married two years later, and he has remained her rock.

She and Larry became parents with the birth of daughter Jennifer. Marilyn was a devoted mother, but she began to suffer bouts of psychosomatic paralysis when her daughter entered puberty and the agonizing memories came flooding back. She dared not reveal the truth while her father was alive, certain that he would kill both her and himself if his violations were exposed.

After her father's death, Marilyn finally went public with her memories of incest at a 1991 press conference sponsored by the Kempe National Center for the Prevention and Treatment of Child Abuse and Neglect, a nonprofit with which she had worked for two years. At the time of her shocking confession, the center launched its Adult Incest Survivors Program, generously funded by the Van Derbur family.

Soon thereafter, Marilyn courageously testified at the request of Colorado's congresswoman, Pat Schroeder, before nine hundred people at a Congressional hearing on family violence in Washington, D.C. All of her years as a respected public figure had led up to this. At last she could speak out about child molestation without fear or shame, awakening public awareness. Her 2003 autobiography, *Miss America by Day: Lessons Learned from Ultimate Betrayals and Unconditional Love*, inspires others with her story and example of triumph over trauma.

Marilyn van Derbur continues to embody the attributes that made her a standout among the first debutantes presented to Denver society at the Brown Palace. As beautiful and regal as ever, she is a lady in the finest sense—gracious, serene and compassionate. To proud Coloradans, she will always be Miss America—the ideal, for real.

ETHEL KENNEDY: CAMPING IN

Americans reeled in shock on June 5, 1968, when Robert F. Kennedy was felled by an assassin's bullet at the Ambassador Hotel in Los Angeles. Senator from New York, former U.S. attorney general and brother of slain president John F. Kennedy, Robert had just won the California primary. The victory was a major step on the way to the Democratic nomination for president. Like his brother John and civil rights leader Martin Luther King Jr., Bobby Kennedy was cut down before he could fulfill his vision for a better America. Hearts went out to his widow, Ethel, pregnant at the time with their eleventh child.

Forty years later, Mrs. Robert Kennedy prepared to attend a special memorial event held in her husband's honor in the Brown Palace's Ellyngton's restaurant. Also staying at the Brown were most of Ethel and Bobby's children and grandchildren, Caroline Kennedy and Senator Edward "Teddy" Kennedy. All were present not only for the RFK tribute but also for the 2008 Democratic National Convention.

It had been one hundred years since Denver last hosted a national political convention. The city had welcomed the Democrats in 1908, when several state delegations and the brother of presidential nominee William Jennings Bryan stayed at the Brown. In the interim, the Mile High City, like the nation, had grown in size

Ethel (Mrs. Robert) Kennedy. *Wikimedia Commons.*

and sophistication. Thanks to careful planning and coordination between Mayor John Hickenlooper, the DNC, the Secret Service and myriad metro law enforcement agencies, the weeklong convention unfolded without incident. Denver basked in the positive national attention and proved it could successfully host a world-class event.

The visit provided a chance for Ethel Kennedy to reminisce about her first stay at the Brown Palace in 1950. She and Bobby were on their honeymoon, taking a road trip through the West. They had made a reservation at the iconic hotel, but they arrived late that evening. Due to a large convention in town at the same time, their room had not been held for them. The credit cards routinely used today to guarantee reservations were nonexistent, and Robert F. Kennedy was years away from national notoriety.

As the disappointed newlyweds were leaving the lobby, they chanced to encounter an old Harvard football teammate of Bobby's. The man owned one of many retail outlets that once encircled the Brown's ground floor. Upon hearing of their predicament, he offered his shop as a place to spend the night. The Kennedys gratefully took him up on his offer. With sleeping bags and air mattresses, they spent the next four nights camping out in the clothing store, launching day trips from their temporary base

at the Brown to the mountains, Garden of the Gods and other nearby tourist attractions.

Ethel shared her delightful memory with the hotel historian while having her hair done in the spa. She wished she could recall exactly where their "camp" had been, but the Brown is much changed since the Kennedys' bivouac adventure. Though their signatures never appeared in an official guest register, Ethel will always remember their unusual stay at Denver's premier hotel with a smile.

HILLARY RODHAM CLINTON: SECOND TO NONE

All three of the Brown Palace presidential suites were named for Republicans: Dwight Eisenhower, Theodore Roosevelt and Ronald Reagan. Given that the hotel has always catered to the conservative and affluent, it is probably no coincidence. It could have been, however, a bit off-putting to the many prominent Democrats expected for the 2008 national convention.

In deference to its DNC guests, the hotel decided to temporarily rename one of its presidential suites the Obama Suite, honoring the party's presumed presidential nominee, Illinois senator Barack Obama. Decorative photos and memorabilia were replaced with Obama family pictures throughout the suite, and everything seemed to be in order to welcome the Democrats.

The Obamas' hotel was selected for them by the Secret Service, which of course sought the most easily secured downtown venue. As it turned out, the Westin Tabor Center best met their criteria and was honored to host the future president, First Lady and First Kids. And who was assigned to the "Obama Suite" at the Brown? Hillary Rodham Clinton, the first serious female contender for the presidential nomination in U.S. history.

Senator Clinton had run a close race, and her concession to challenger Barack Obama was still fresh in August 2008. When the hotel learned, at the last minute, that Hillary would be occupying the renamed presidential suite, the original décor and name were hastily restored to ensure that the honored guest would have no cause to be uncomfortable. Hillary's one request that was that a regular-sized mattress be substituted for the very high mattress usually crowning the suite's bed. Daughter Chelsea made herself at home in the large bedroom and bath adjoining the presidential suite, and Secret Service agents kept a watchful eye on both of them.

Hillary Clinton's visit was a high point of the week packed with triumphs for the host city and the Brown Palace. The hotel's management and staff stepped up to the challenges presented by Mrs. Clinton's busy schedule. The senator so enjoyed the Afternoon Tea served in her suite that she bought some of the Brown's special tea to take home with her. Creative logistics and diversionary tactics got her and her staff in and out of the hotel throughout the week with as little fuss as possible. Admiring supporters who waited for a glimpse of their candidate rarely got the chance.

The 2008 DNC was not Hillary's first visit to the Brown. She had accompanied her husband, President Bill Clinton, to Denver in 1997 for the Economic Summit of the Eight. Both the United States and Italian delegations stayed in Denver's Brown Palace for the weeklong conference, which also brought together the leaders of Great Britain, Canada, France, Germany, Japan and—invited for the first time that year—Russia. Russian president Boris Yeltsin posed for photos with President Clinton on the second-floor mezzanine overlooking the flags above the hotel's Grand Staircase.

While the "Global Board of Directors" met during the day, the international leaders' wives were escorted on sightseeing excursions. Noted Colorado historian Tom Noel, who hosted the First Ladies on a train trip to Winter Park, remembered Hillary as unfailingly warm and gracious, despite a throbbing headache she confessed only to him. When townspeople at one stop along their rail route thronged the train waving American flags, Mrs. Clinton was concerned that her peers from the other countries were being overlooked. But her smile reappeared at a subsequent whistle stop where schoolchildren waved flags of all the participating nations in enthusiastic welcome.

Ten years later, stepping out of the shadow of her husband's besmirched record as commander in chief, Hillary announced her intention to run for the Democratic presidential nomination. Her political agenda focused on the needs of families and average Americans. Support for universal healthcare, reproductive choice, embryonic stem cell research, women's equality and gay rights attracted legions of loyal liberals to her campaign.

The primary race was tight and went on longer than expected. Although Senator Obama won more convention delegate votes, Senator Clinton claimed a majority in the popular votes. When Obama clinched the party's nomination with more endorsements from so-called superdelegates (party leaders and elected officials), many of Clinton's staunchest supporters refused to accept the defeat. Some even threatened to vote Republican rather than endorse Hillary's former opponent. A few embittered supporters

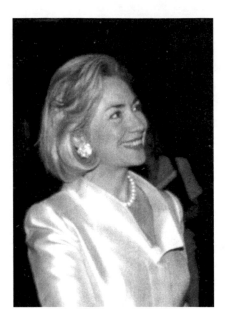

Hillary Clinton at the Brown for Summit of the Eight, 1997.

elected to bide their time at the Brown rather than attend Obama's historic acceptance speech in Invesco Field at Mile High Stadium.

Hillary herself, however, was a veteran of compromise. She knew when to cast her lot with the people's choice for the good of the party and of the country. When Barack Obama became the nation's first black president, he appointed Senator Clinton as U.S. secretary of state. Hillary succeeded two other women in that key cabinet position—Madeleine Albright and Condoleezza Rice, both of whom have strong Denver connections and have stayed at the Brown when in the city.

The hotel's reputation as the choice of influential politicians and statesmen remains intact. The percentage of women within those ranks continues to increase, approaching the wildest dreams of suffragists a century ago. When the first female president inevitably makes history in the near future, she will be welcomed at Denver's Grande Dame, regardless of her party affiliation.

Epilogue

The ladies featured in this book cover a broad historical spectrum, from generations past through only yesterday and from pioneers to politicians. Many of them share interconnections and character traits, but each is entirely individual. What they have in common is ultimately a place—a very special place called the Brown Palace. Whether they merely passed through, spent one night or a dozen, worked there, danced there, lived there or died there, Denver's most iconic hotel touched them all in indelible ways.

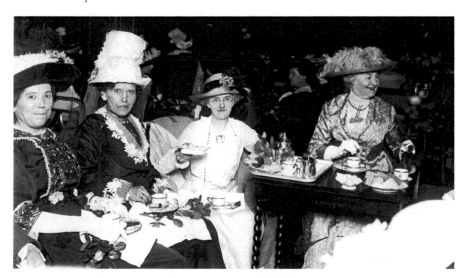

Ladies enjoying Afternoon Tea at the Brown, circa 1910.

Afternoon Tea, 2010. *Courtesy James Faulkner.*

The Brown Palace remains the repository of memories for countless women. Both personal and public histories continue to unfold within the hotel's walls. And Denver's Grande Dame embraces all who enter.

Shakespeare might just as well have written "Age cannot wither, nor custom stale her infinite variety" of the Brown as of Egyptian queen Cleopatra. A magic and a majesty pervade the hotel, transforming the everyday into the elegant and consistently exceeding expectations. Forever the confederate of influential gentlemen, the Brown Palace is no less a cordial consort for the ladies who grace her premises.

The great human tide which daily flows through its halls is made up chiefly of transient waves of humanity. Still…in time, it cannot fail to become rich in all those associations which make an abiding place a true home.
—The Brown Palace Hotel, *in-house publication, circa 1893*

Timeline

"Pikes Peak or Bust" gold rush gives rise to Denver.	**1859**	
	1860	Jane Brown persuades husband Henry to settle in Denver.
The Colorado Territory is created.	**1861**	
The Civil War ends.	**1865**	
Henry C. Brown gives Colorado site for capitol building.	**1868**	
Colorado becomes a state.	**1876**	
Colorado's silver boom begins.	**1877**	

Construction begins on Brown Palace.	**1888**	
Brown Palace opens on August 12.	**1892**	Augusta Tabor moves into the Brown.
"Silver Crash" sends Colorado's economy into a recession.	**1893**	Colorado women win the vote.
Winfield Scott Stratton acquires the Brown Palace.	**1900**	Margaret Brown throws Thanksgiving feast for Denver urchins. Kittie Wilkins brokers biggest horse trade in U.S. history.
Denver hosts first National Western Stock Show.	**1906**	Sarah Bernhardt performs at Elitch's Theatre in the Gardens.
Denver hosts the Democratic National Convention.	**1908**	Louise Hill compiles first *Who's Who in Denver.*
	1909	Emily Griffith co-founds the Denver School Dames.
	1911	Isabel Springer triggers murder at the Brown Palace.
Sinking of the *Titanic.*	**1912**	Josephine Roche is appointed "Inspector of Amusements."
Prostitution is outlawed in Denver.	**1913**	

Colorado goes "dry."	**1916**	
The United States enters World War I.	**1917**	
Eighteenth Amendment mandates nationwide Prohibition.	**1919**	
Nineteenth Amendment grants all U.S. women the vote.	**1920**	
	1921	Jascha Heifetz plays private concert for Helen Keller.
Charles Boettcher and Horace Bennett acquire the hotel.	**1922**	
	1926	Queen Marie of Romania tours the United States.
	1927	Jacqueline Hoefler moves with family into the Brown.
The Stock Market Crash.	**1929**	
The Great Depression.	**1930s**	
	1932	"Babe" Didriksen visits Denver with U.S. Women's Olympic track and field team.
Prohibition is repealed.	**1933**	
Ship Tavern opens in the Brown Palace.	**1934**	

Fire guts the hotel's Casanova Room.	**1935**	
	1936	Edna Stewart takes dictation from Eleanor Roosevelt.
Allen Tupper True paints elevator lobby murals. Skyline Apartments open on hotel floors eight and nine.	**1937**	Evalyn Walsh McLean throws impromptu banquet at the Brown.
The United States enters World War II.	**1941**	
	1943	Rosalie Soper assumes executive housekeeper duties at the Brown.
Lobby steer exhibition tradition begins.	**1945**	
The Palace Arms restaurant opens.	**1950**	Jessie Thornton becomes Colorado's First Lady. Ethel and Bobby Kennedy honeymoon in the West.
	1952	Mamie Eisenhower becomes First Lady.
First Denver Debutante Ball.	**1955**	
	1956	Marge and Eddie Harmon wed. Jane Tomberlin marries Prince Sam Amalu.

	1958	Marilyn van Derbur is crowned Miss America. Edna Boettcher bequeaths mansion to State of Colorado.
The Brown Palace Tower annex opens. Escalators, skybridge and service tunnel under Tremont are added.	**1959**	
Urban renewal razes many Denver historic buildings.	**1960s–1970s**	
The Brown Palace Club opens.	**1963**	
The Beatles spend a night at the Brown.	**1964**	Debbie Reynolds stars in *The Unsinkable Molly Brown.* Joan Baez performs at Red Rocks Amphitheatre.
Brown Palace is added to National Register of Historic Places.	**1970**	Zsa Zsa Gabor's appearance benefits Dumb Friends League.
	1971	Catherine Rickes Orr begins caring for Mrs. Blackmer.
	1977	Corinne Hunt becomes first hotel historian.
Ellyngton's restaurant opens.	**1985**	

Afternoon Tea service is reinstated in atrium lobby.	**1986**	
	1987	Marietta Bakewell parts with "Sir Galahad."
The Brown Palace is named a Denver Landmark.	**1989**	
	1995	Barbara Goodrich begins playing harp for Afternoon Tea.
Denver hosts Economic Summit of the Eight.	**1997**	
Roosevelt and Reagan Presidential Suites are added.	**2000**	
The Brown Palace Spa opens.	**2005**	
Denver hosts the Democratic National Convention.	**2008**	Hillary Clinton speaks at Democratic National Convention.
Brown Palace pioneers rooftop urban beekeeping.	**2010**	

Recipes from the Brown Palace

BROWN PALACE SCONES

Add currants to re-create a favorite from Afternoon Tea in the atrium lobby.

3 cups flour
1 tablespoon baking powder
5 tablespoons butter
$^1/_3$ cup sugar
3 eggs, plus additional egg for egg wash
$^1/_4$ cup buttermilk

Mix flour and baking powder. Cut butter into flour mixture. Add the sugar, eggs and buttermilk and blend just until mixture comes together. Do not overmix. Chill in bowl for at least one hour.

Roll chilled dough onto floured surface to $^1/_2$-inch thickness. Using biscuit cutter, cut $2^1/_2$-inch circles. Brush with egg wash (whisk together one egg plus one tablespoon of water). Place scones on parchment-lined baking sheet. Bake at 375 degrees for fifteen minutes or until golden brown. Yields eighteen scones.

DOUBLE-CHOCOLATE BROWNIES

The only thing more popular than Afternoon Tea? Chocolate Afternoon Tea!

1 ¼ cups all-purpose flour
½ teaspoon soda
¼ teaspoon salt
½ cup butter
2 cups semisweet chocolate chips
3 eggs
1 teaspoon vanilla
1 cup sugar
⅓ cup chopped nuts

Preheat oven to 350 degrees. Grease a 13- by 9- by 2-inch baking pan. Combine flour, soda and salt. In a large saucepan over low heat, melt butter and half of the chocolate chips, stirring until smooth. Whisk together eggs, vanilla and sugar and stir into batter. Stir in the flour mixture. Remove from heat and allow to cool.

Stir in remaining chips and nuts. Spread into prepared pan. Bake eighteen to twenty-two minutes. Cool completely. Cut into twenty-four brownies.

IMPERIAL PUNCH

Served as a palate cleanser in the middle of multicourse 1890s dinners. Updated for the hotel's 1992 centennial.

1 scoop crushed ice
¾ oz. Chambord
¾ oz. Bacardi Silver rum
¾ oz. Midori melon liqueur
8 oz. pineapple juice
2 oz. cranberry juice
1 splash lime juice
1 swirl grenadine

Put scoop of ice into blender. Add Chambord, rum, melon liqueur, juices and grenadine. Blend until frozen. Serve in margarita glasses.

ROCKY MOUNTAIN TROUT AND EGGS

A versatile dish from the early 1900s, served for breakfast, lunch or dinner.

1 cup flour
1 tablespoon salt
1 teaspoon ground white pepper
4 five-oz. trout fillets
egg wash (two eggs whisked with one cup water or milk)
1 cup cornmeal
$^1/_8$ cup butter
8 eggs
hash brown potatoes

Mix flour with salt and pepper. Coat trout fillets in flour mixture, dip in egg wash and coat with cornmeal. Sauté in hot skillet with butter until golden brown, turning once, skin side up first.

Serve with two eggs, cooked as desired, and hash browns. Serves four.

ZERO SALAD

Created for post–heart attack President Dwight Eisenhower by Brown Palace chef Ira Dole, and a hit with First Lady Mamie, the "zero" refers to number of calories.

$^2/_3$ cup tomato juice
2 tablespoons fresh lemon juice or vinegar
1 tablespoon finely chopped onion
salt and pepper to taste
1 head bib lettuce

Combine first four ingredients in small bowl and whisk together well. Break lettuce into bite-sized pieces, toss with dressing and serve.

COFFEE SPICE STEAK RUB

Created by Executive Chef Bill Dexter for the 2010 Debutante Ball.

¼ cup chili powder
¼ cup fine ground coffee
2 tablespoons paprika
2 tablespoons brown sugar
1 teaspoon dry mustard
1 teaspoon salt
1 tablespoon ground black pepper
1 tablespoon ground coriander
2 teaspoons ground ginger (dry)

Combine all ingredients well. Apply liberally to beef or chicken and then sear, bake or grill to desired doneness.

Hotel restaurant, circa 1905.

Bibliography

Books

Abbott, Carl, Stephen J. Leonard and Thomas J. Noel. *Colorado: A History of the Centennial State.* 4th ed. Niwot: University Press of Colorado, 2005.

Bancroft, Caroline. *The Brown Palace in Denver: Hotel of Plush, Power and Presidents.* Denver, CO: Golden Press, Inc., 1955.

————. *The Unsinkable Mrs. Brown.* Boulder, CO: Johnson Books, 1961.

Bean, Geraldine B. *Charles Boettcher: A Study in Pioneer Western Enterprise.* Boulder, CO: Westview Press, Inc., 1976.

Dier, Caroline Lawrence. *The Lady of the Gardens: Mary Elitch Long.* Hollywood, CA: Hollycrofters Inc., Ltd., 1932.

Everett, Derek R. *The Colorado State Capitol: History, Politics, Preservation.* Boulder: University Press of Colorado, 2005.

Faulkner, Debra B. *Touching Tomorrow: The Emily Griffith Story.* Palmer Lake, CO: Filter Press, 2006.

Furman, Evelyn E. Livingston. *My Search for Augusta Tabor, Leadville's First Lady.* Denver, CO: Quality Presss, 1993.

Hull, Betty Lynne. *Denver's Elitch Gardens: Spanning a Century of Dreams.* Boulder, CO: Johnson Books, 2003.

Hunt, Corrine. *The Brown Palace: Denver's Grand Dame.* Denver, CO: Brown Palace Hotel, 2003.

———. *The Brown Palace Story.* Denver, CO: Brown Palace Hotel, 1982.

Iversen, Kristen. *Molly Brown: Unraveling the Myth.* Boulder, CO: Johnson Books, 1999.

Kreck, Dick. *Murder at the Brown Palace: A True Story of Seduction & Betrayal.* Golden, CO: Fulcrum Publishing, 2003.

Lennon, Elzabeth B. *Representative Women of Colorado.* Denver, CO: Alexander Art Publishing Company, 1911.

Leonard, Stephen J., and Thomas J. Noel. *Denver: Mining Camp to Metropolis.* Boulder: University Press of Colorado, 1990.

Lohse, Joyce B. *Emily Griffith: Opportunity's Teacher.* Palmer Lake, CO: Filter Press, 2005.

———. *Unsinkable: The Molly Brown Story.* Palmer Lake, CO: Filter Press, 2006.

McLean, Evalyn Walsh. *Father Struck It Rich.* Ouray, CO: Bear Creek Publishing, 1907.

Moynihan, Betty. *Augusta Tabor: A Pioneering Woman.* Evergreen, CO: Cordillera Press, 1988.

Noel, Thomas J. *Riding High: Colorado Ranchers and 100 Years of the National Western Stock Show.* Boulder, CO: Fulcrum Publishing, 2005.

Preston, R.L. *Stetson, Pipe, and Boots: Colorado's Cattleman Governor, Dan Thornton.* Victoria, BC: Trafford Publishing, 2006.

Riley, Marilyn Griggs. *High Altitude Attitudes: Six Savvy Colorado Women.* Boulder, CO: Johnson Books, 2006.

BIBLIOGRAPHY

Smith, Jean W., and Elaine C. Walsh. *Queen of the Hill: The Private Life of the Colorado Governor's Mansion.* Denver: Volunteers of the Colorado Historical Society, 1979.

Varnell, Jeanne. *Women of Consequence: The Colorado Women's Hall of Fame.* Boulder, CO: Johnson Books, 1999.

MAGAZINES

Colorado Heritage
Idaho Magazine
Texas Highways

NEWSPAPERS

Denver Daily News
Denver Post
Denver Republican
Denver Times
Idaho State Journal
Rocky Mountain News
Telluride Times
World Register (Brown Palace employee newsletter)

Index

About the Author

D ebra Faulkner grew up in Loveland, Colorado, and came by her love of local history honestly, touring and living around the state throughout her life. Her first memory of the Brown Palace dates to a visit from a wealthy uncle of her mother's, who treated them to dinner in the Palace Arms and bought Debra her first cocktail—a Shirley Temple. She kept the plastic sword and paper parasol as mementos for years.

Faulkner earned her bachelor's degree in education and master's in history from the University of Colorado. She currently teaches U.S. and Colorado history courses at Metropolitan State College on the Auraria campus in the heart of downtown Denver. Her passion for women's history led her to serve on the board of the Colorado Women's Hall of Fame for three years and to create the archives for that organization.

Faulkner authored the award-winning biography *Touching Tomorrow: The Emily Griffith Story* (Filter Press, 2005) and *Mary Elitch Long: First Lady of Fun* (Filter Press, 2008), as well as several books on Colorado history in collaboration with Thomas J. Noel. Since 2008, Faulkner has served as hotel historian and archivist for the Brown Palace Hotel and Spa. She conducts tours, presents programs, responds to inquiries and preserves the hotel's artifacts and stories for future ladies—and gentlemen—of the Brown.

Visit us at
www.historypress.net